Monet's Palate Cookbook

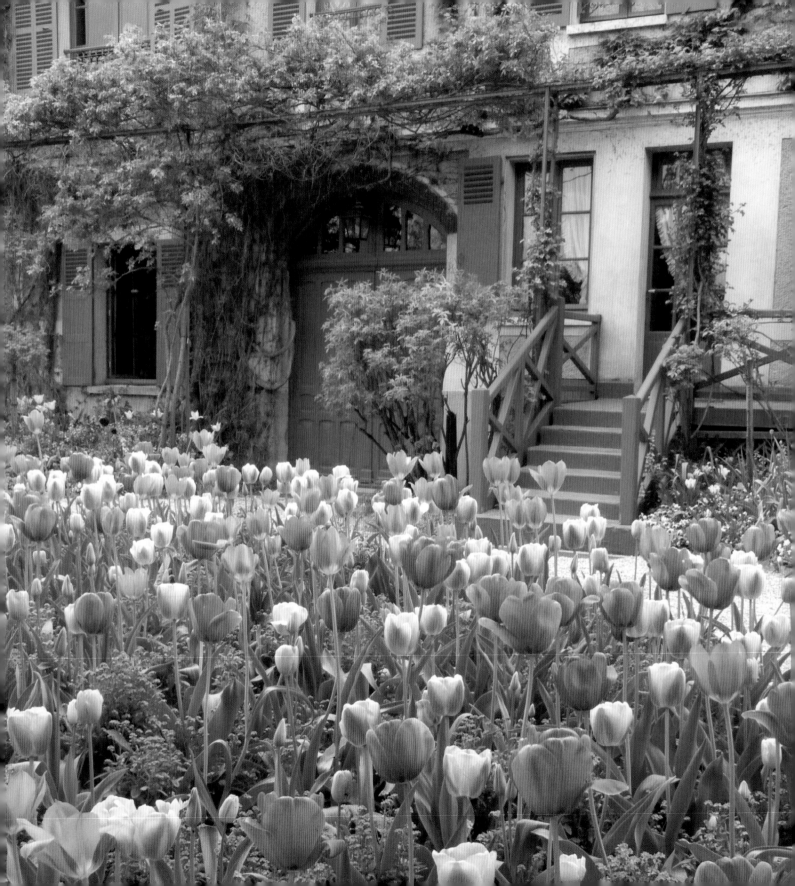

Monet's Palate Cookbook

THE ARTIST & HIS KITCHEN GARDEN AT GIVERNY

AILEEN BORDMAN & DEREK FELL

Photography by Derek Fell

with additional food photography by Steven Rothfeld

Foreword by Meryl Streep

GIBBS SMITH
TO ENRICH AND INSPIRE HUMANKIND

To my mother, Helen Rappel Bordman, who has inspired us all
to seek the beauty in Monet's world. —Aileen Bordman

To the memory of my mother, Mary Woodhouse Fell, who saw in me an early
aptitude for photography and garden writing, and encouraged me. —Derek Fell

16 17 18 19 20 10 9 8 7 6 5

Published by
Gibbs Smith
P.O. Box 667
Layton, Utah 84041

1.800.835.4993 orders
www.gibbs-smith.com

Designed by Rita Sowins
Pages production by Melissa Dymock
Printed and bound in Hong Kong

Gibbs Smith books are printed on paper produced from sustainable PEFC-certified
forest/controlled wood source. Learn more at www.pefc.org.
Printed and bound in Hong Kong

Library of Congress Cataloging-in-Publication Data
Bordman, Aileen.
Monet's palate cookbook : the artist & his kitchen garden at Giverny / Aileen Bordman & Derek Fell ; photography by
Derek Fell ; with additional food photography by Steven Rothfeld ; foreword by Meryl Streep. — First edition.
pages cm
Includes index.
ISBN 978-1-4236-3997-8
1. Cooking, French. 2. Kitchen gardens—France—Giverny. 3. Gardens in art. 4. Monet, Claude, 1840-1926—Homes
and haunts. 5. Monet, Claude, 1840-1926—Themes, motives. I. Fell, Derek. II. Rothfeld, Steven. III. Title.
TX719.B67328 2015
641.5944—dc23
2014042025

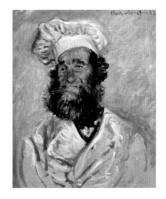

"You are about to embark on a culinary tour of
Claude Monet's beloved Normandy, a region of France
just north of Paris along the Seine River.
This region inspired Monet's passion for art and his
passion for fine cuisine. Both of Monet's palates [and palettes]
met at his home in Giverny surrounded by
his beautiful gardens. Join us as we explore the cuisine
and life Monet loved and adored."

—MERYL STREEP, IN THE DOCUMENTARY FILM

MONET'S PALATE: A GASTRONOMIC VIEW FROM THE GARDENS AT GIVERNY

Contents

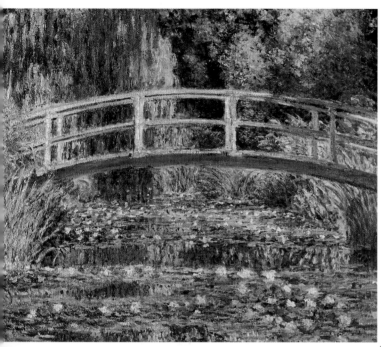

"April will be here and Monet will refuse to budge."

—ALICE HOSCHEDÉ,
Monet's wife, in a letter

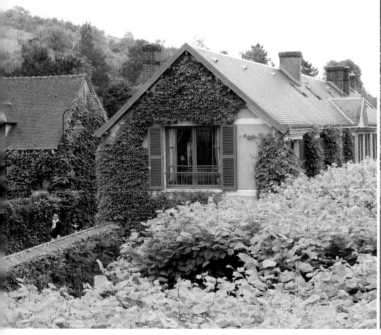

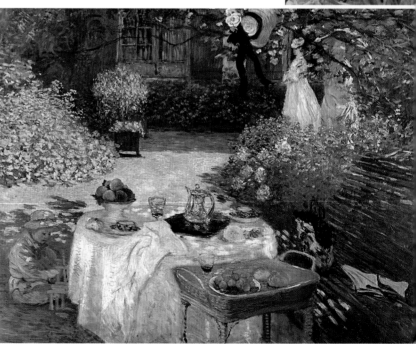

Foreword

CLAUDE MONET WAS MUCH MORE THAN AN ARTIST. Although he claimed to be good at only two of life's endeavors—painting and gardening—he lived a life that included entertaining leaders in art and politics in the large dining room of his beautiful home in the bucolic Normandy countryside.

However, in addition to the famous home and magnificent flower garden at Giverny, hidden away at the other end of the village was his bountiful two-acre vegetable garden. It was cared for by his *potager* gardener Florimond, who lived at La Maison Bleue (the Blue House), near Monet's home, and who toiled at maintaining a constant supply of fresh produce during the growing season for Monet's family and many illustrious guests.

Almost twenty years ago my mother and I had the honor of visiting Giverny—Monet's house, the flower garden and adjacent water garden. We were greeted with kindness by Helen Rappel Bordman, who, I later learned, had been part of the renaissance of Monet's home and garden at Giverny. We visited the interior of his home, including his splendid kitchen and bright yellow dining room. The fact that Monet was as passionate about his garden and cuisine as he was about his art was enchanting. Our visit to Normandy, with its special quality of sunlight, terrain and beauty, made visually apparent to us why the unique light, the play of shadow and mist, first attracted Monet and other Impressionists to this province. In addition, the delicious bounty of Normandy, including its prized apples, cheeses and butter, are so distinct from the other regions of France we had visited.

I am happy to see that the authors, Aileen Bordman and Derek Fell, have not restricted their focus to Monet's culinary interests and his kitchen garden, but also reference his home's interior, which is really an extension of his art, and the flower garden, which Monet declared to be "my one and only masterpiece." Treated individually they each represent fragments that complete an entrancing picture of what might be described as one of the happiest households in France. The wonderful farm-to-table aspect of Monet's time has once again become relevant in the twenty-first century. With this in mind, I am so happy that the recipes and photography in *Monet's Palate Cookbook* have brought Claude Monet's beloved kitchen garden back to life.

—MERYL STREEP

Monet's Passion for Good Food

> "I want to put in an order for two bottles of champagne and some morel mushrooms—that's what I fancy for some reason . . . "

> —MONET, TO HIS WIFE, IN A LETTER FROM ITALY

MONET'S PALATE COOKBOOK: THE ARTIST AND HIS KITCHEN GARDEN AT GIVERNY is a unique culinary journey into the fascinating world of Claude Monet, his extraordinary kitchen garden and his taste for fine food. Monet surrounded himself with beautiful flower, fruit and vegetable gardens and developed a gourmet palate, supplying his table with the best of ingredients and even raising his own free-range chickens, turkeys and ducks. All of this provided motifs for his work and inspiration for his table.

Monet's Palate will be your culinary guide to a "life well lived," formulated by Monet more than a hundred years before the importance of the farm-to-table or garden-to-table lifestyle was fully appreciated. His desire for fresh garden vegetables and herbs extended beyond the flavor and health benefits that they could provide. His need to cultivate a kitchen garden, plant seeds and work the soil with his fingers allowed him to connect with nature in a spiritual way, feed his soul and see beauty oblivious to others.

From Calvados apple liqueur to Camembert cheese, the wonderful Normandy cuisine serves as a backdrop to Monet's rarefied culinary passion. His quest to travel the world in search of stimulating artistic motifs was also driven by his desire to discover new foods, memorable restaurant recipes and the finest strains of vegetable seeds for his kitchen garden. These discoveries were brought back to Giverny in fat recipe-filled notebooks for Marguerite, his cook, to replicate and serve in his radiant yellow dining room. The precious seeds carried in his pockets were for Florimond—in charge of his large kitchen garden—to grow outdoors if they were hardy, and

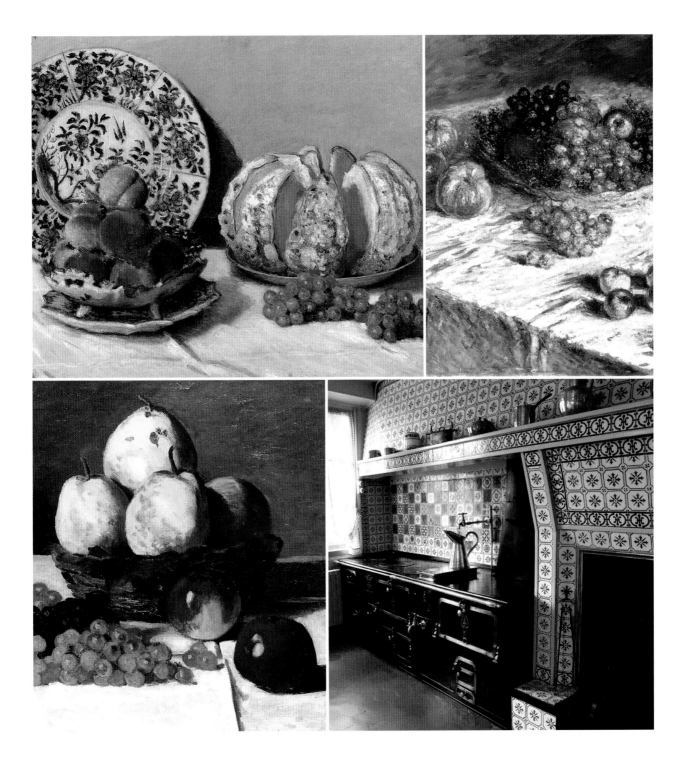

in cold frames if they needed more heat than the relatively cool Normandy climate could provide.

Considered by many to be the father of Impressionism, Claude Monet was one of a group of avant-garde painters who rebelled against traditional concepts of artistic merit. Until the invention of photography, a work of art was judged by its realism. When artists realized that it was impossible to be more realistic than a photograph, they sought new ways of artistic expression. Monet said it best when he told a journalist: "I paint what I see; I paint what I remember and I paint what I feel." It was what an artist felt about a subject that broke with tradition. Because this new style of painting was so different from classical art, and represented what an artist saw with his inner eye, it took a long time for the public to appreciate its value. Until his mid-forties Monet struggled to earn a living. Only when his work began to sell to American collectors was he able to purchase his own home in Giverny and live the good life of a largely self-sufficient lifestyle.

Almost every franc that he earned, after taking care of his family's welfare, he would spend on the freshest ingredients for meals and improving the interior and exterior of his house. Originally a farmhouse with a cider press and called Le Pressoir, it became better known as the "Pink House" for the brick dust used to color its stucco façade. With the help of his second wife, Alice, his two sons and six stepchildren (four girls and two boys), he cleared the site to plant gardens. The gardens initially provided flowers for still-life paintings when the weather would not allow

him to paint in the surrounding countryside, and they satisfied his craving for fresh vegetables.

Although Monet never painted his kitchen garden, we know what it looked like from a painting by the American Impressionist artist Willard Metcalf, who was given Monet's permission to paint it after a visit to Giverny. Titled *Monet's Formal Garden*, it shows square and rectangular beds hedged by herbaceous peonies in full bloom and lines of fruit trees espaliered against the boundary walls. On page 14 is a small-scale layout designed and planted to honor Monet's kitchen garden.

Monet's love of fine dining extended to designing his own yellow-and-blue-patterned dinnerware of Limoges china (seen on page 129) and inviting some of the most talented creative minds of the day to share his world. Monet's home welcomed artists such as Renoir, Caillebotte and Cezanne; art dealers such as Durand-Rouel and Theo van Gogh; politicians such as Prime Minister Clemenceau; and literary giants such as Mirbeau. Life revolved around his table, and when important guests arrived, his cuisine, the gardens and his art became intertwined to create a remarkable lifestyle summarized in the expression *Monet's Palate*.

Although Monet's domestic life before Giverny had been a struggle to make ends meet and he spent many months unable to paint, he employed a cook and when he settled into the Giverny house established a strict regimen around his work. Most days he would rise at first light at 5:00 a.m. and explore the country-

An 1895 painting by the American Impressionist artist Willard Metcalf titled Monet's Formal Garden.

side looking for motifs. He would return by 7:00 a.m. to eat a hearty English-style breakfast, usually consisting of free-range eggs from his own chickens, local cured bacon and pork sausages, along with toast and marmalade and dark-roast coffee. He enjoyed croissants and slices of baguette, which he might eat with homemade blackcurrant or gooseberry jam. By 9:00 a.m. he would be out the door again, usually accompanied by his oldest stepdaughter, Blanche, who was a talented artist herself. She invariably helped him with

his easel, canvases and other painting paraphernalia.

Since the early afternoon was his least favorite time of day because of the harsh light, Monet usually liked to lunch promptly at 11:30 a.m., and it was during lunch that he might entertain visitors. He reserved dinnertime to be with his family, beginning with soup at 5:30 p.m. He would seat himself at the head of the table and insisted on carving the

meat dish. He also required two salad bowls—one seasoned heavily with pepper to suit his taste and a separate mix for his family. After dinner he and his family might then retire to the adjacent salon to read and talk, or to Monet's more spacious first studio, which served as a drawing room.

The late Gerald Van der Kemp, chief curator of Monet's house and garden, discovered that André Deviller, former director of the Etablissements Horticoles Georges Truffaut—the nursery near Versailles that Monet patronized—had lunched with Monet every week over many years, discussing plants that Monet wanted to obtain for his gardens. When Deviller heard of plans to restore Monet's prop-

erty, though retired, he offered to help. He not only described the room interiors and the meals served but also remembered the plants that were in the garden.

The spectacular increase in home vegetable gardens, even on rooftops in urban areas; the demand for fresh, locally grown and organically raised vegetables; and the proliferation of farmers' markets nationwide is evidence that people aspire to the model that Monet established with his kitchen garden and passion for good food. Through recipes and beautiful photography, *Monet's Palate Cookbook* captures the essence of Monet's cherished way of life. Come; turn the pages to begin your journey.

PLAN FOR A SMALL-SPACE KITCHEN GARDEN

Monet's kitchen garden was 2½ acres, obviously too large for most people to contemplate. But Derek Fell created a design based on Monet's layout of geometric-shaped beds at his home, Cedaridge Farm, in Bucks County, Pennsylvania. The planting plan, using raised beds to provide good soil depth and excellent drainage, shows a quadrant design featuring Monet's favorite vegetables, notably annual cool-season crops that are easy to grow from seed. Space is also provided for warm-season crops like snap beans, cucumbers, summer squash, tomatoes, peppers and eggplant. Bamboo stakes create a trellis for vines to grow vertically, saving valuable space.

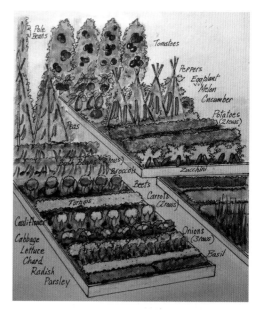

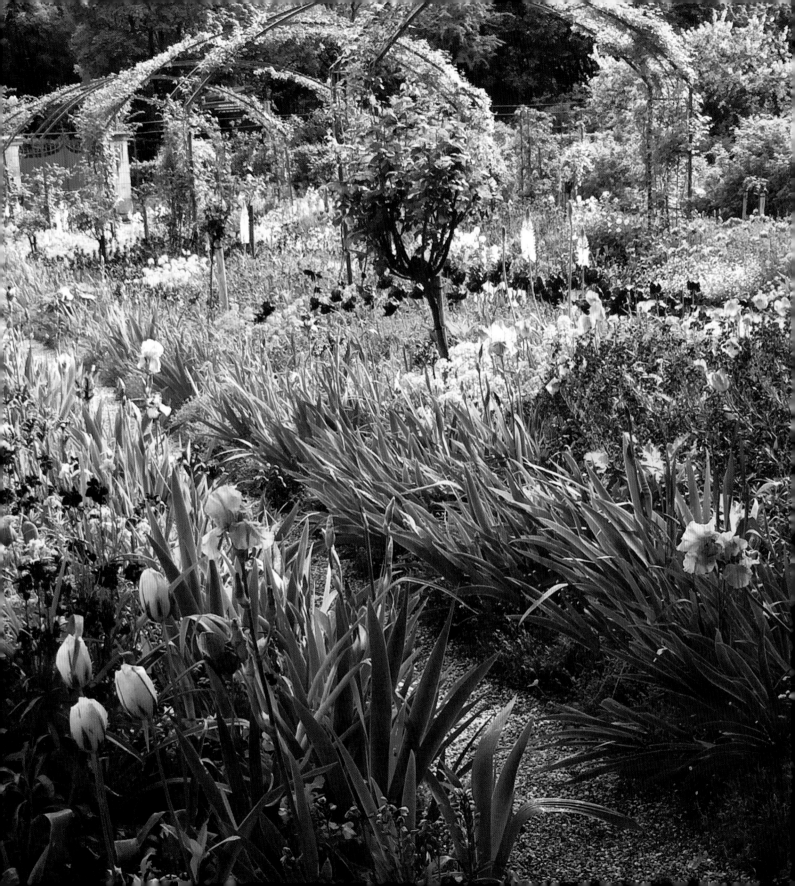

Monet's Home

BEFORE SETTLING DOWN TO LIVE IN THE VILLAGE OF GIVERNY, Monet had rented a series of smaller properties and never felt rooted until he moved to the Pink House in 1883, at age 43. He was to spend the rest of his life pouring his heart, soul and most of his earnings into developing a comfortable, almost self-sufficient lifestyle that revolved around the house, with its bountiful gardens, and his love of fine cuisine.

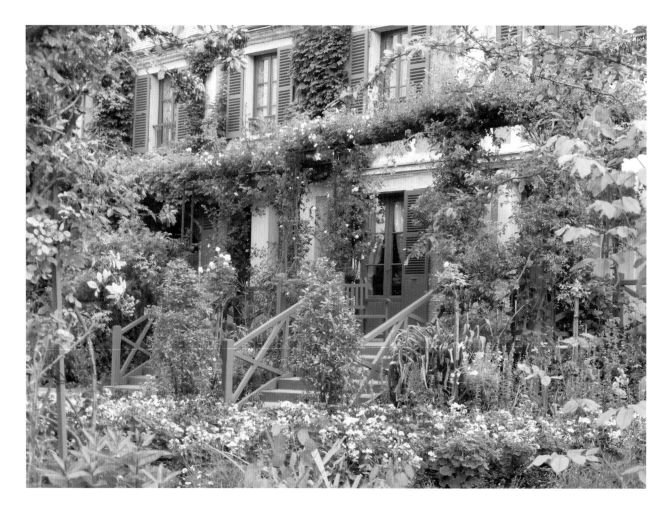

MONET'S HOUSE

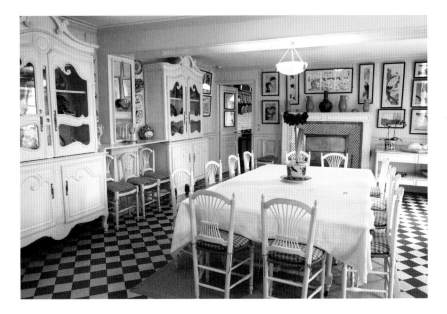

THE YELLOW ROOM—THE DINING ROOM. It is evident from its relatively large size and cheerful decoration that Monet considered the dining room to be the most important room in the house. It has a wood-burning fireplace, and the space is lit by a pair of large windows facing south into the garden. Its canary-yellow color gives it a sunny atmosphere. Monet often breakfasted here alone.

THE KITCHEN. Monet's spacious kitchen adjoins the dining room. The main color palette is blue and white, mostly from blue-and-white tiles that were manufactured locally, in Rouen. A door opens out to the farmyard, where eggs were easily collected from chicken pens. Another door leads to the cellar, where shelves provided space for storage of fruits, vegetables and wine.

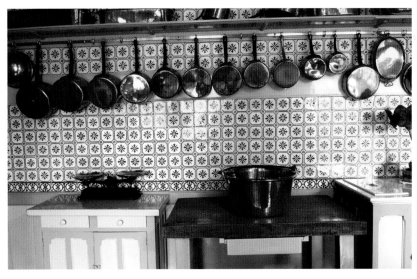

THE BLUE ROOM (SALON).

A small, intimate room is where Monet and his family gathered after meals to talk, read, sew, play card games and listen to music. The walls are covered with framed Japanese prints; there is also a tall floor-to-ceiling clock in one corner, and a built-in bookcase with ornate metal locks.

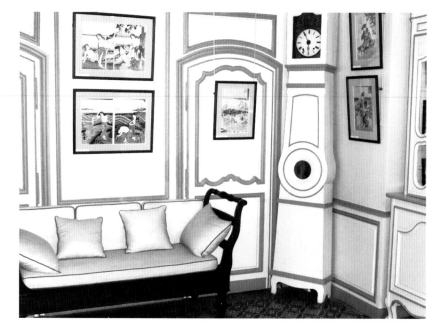

MONET'S BEDROOM.

Monet often spent the entire day in the bedroom, taking a break from painting or from demands of his family, even taking meals there. The walls are crammed with paintings by other painters he admired, especially Cezanne.

MONET'S FLOWER GARDEN

"Everywhere you turn—around your feet, above your head, at chest level—there are cascades, garlands and hedges of flowers, whose color harmonies are at once natural, yet calculated and which renew themselves each season."

—ARSENE ALEXANDRE,
Le Figaro newspaper

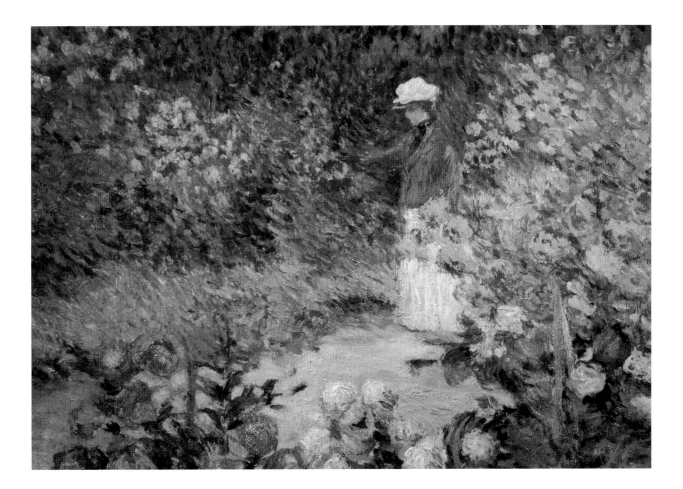

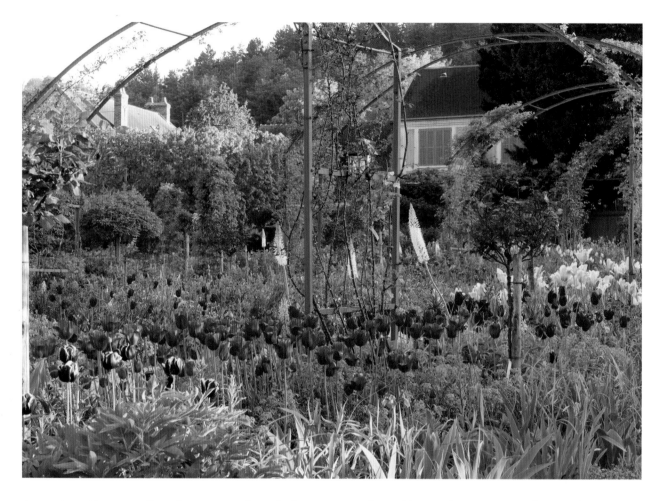

Art critic Clement Greenberg once described an Impressionist painting as "a foaming, pouring, shimmering profusion like nothing else in painting; pictures that are spotted and woven with soft, porous colors, and look in themselves like soft bouquets of flowers." Although he was describing the effect of paint on canvas, this description could well have described Monet's flower garden.

Monet considered his garden a work of art, using the earth and sky as his canvas and plants as paint.

He planted his garden to create effects with color and light that he learned from his experience as an artist. Color combinations used throughout the garden can generally be classified as "hot" (white, yellow, orange and red) or "cool" (green, blue, purple and mauve). He invariably introduced into his garden color harmonies he observed in nature during his plein air painting excursions. For example, the colors blue, pink and white he encountered during a trip to the Cote d'Azur along the shores of the Mediterranean

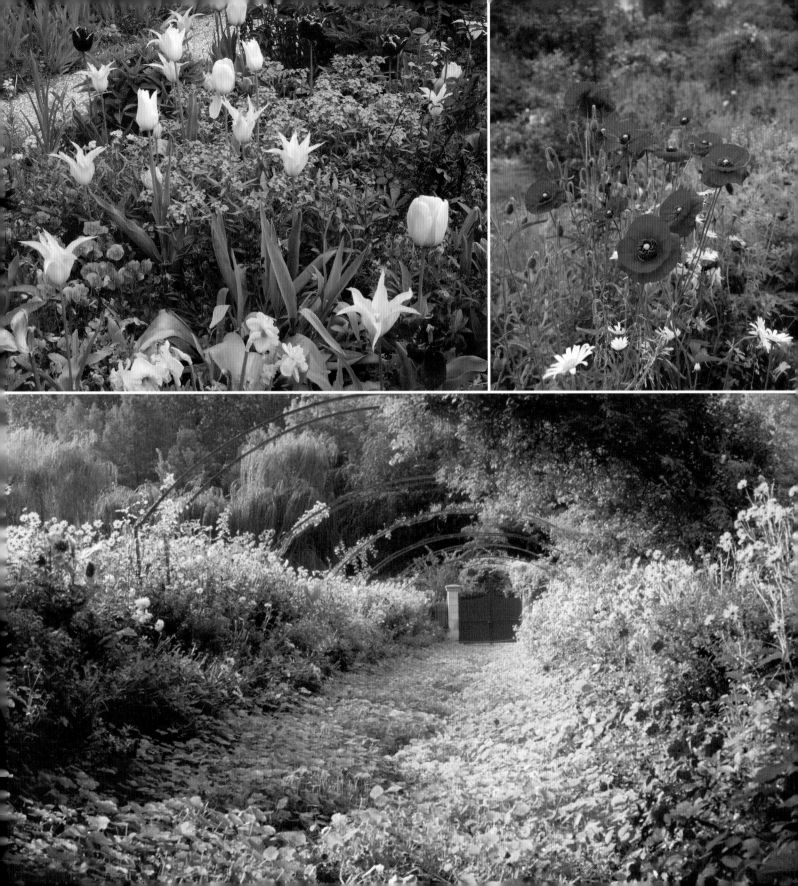

where the blue of the sea, the white of limestone cliffs and pink sunsets often color the late afternoon landscape.

Another striking color harmony from nature seen in Monet's garden is red, pink, green and silver, notably in the island beds in front of the main house. In summer the red comes from bedding geraniums, pink from tree-form roses, silver from a silvery-leafed dianthus, and green from the vigorous geranium and rose foliage. The idea for this particular grouping he discovered in a green meadow at the rear of his residence, where red and pink poppies colonized a slope and silvery wild sage tinted the hillside. He immortalized this scene in his painting titled *Poppy Field.*

Some of the more unusual color combinations in the garden are orange and black and black and white. Although Monet avoided the use of black in his paintings in order for them to look bright, he nevertheless used black as a stipple effect to show pinpricks of shadow.

While coal black flowers are rare in nature, 'Queen of the Night' tulip is an example of a black flower that is used in the garden to contrast with white violas. There are also black pansies and many white flowers with black eye zones, such as white Oriental poppies with black patches at the base of each petal and African daisies with black button centers.

In his paintings Monet often used a dab of white to enhance a solid color, helping to make his work luminescent. In nature, certain flowers like delphinium and lupine have a splash of white at the center of the flower to brighten a solid color, like blue and red. Monet was expert at painting water, rippled by the wind to create pinpricks of light, called shimmer. He introduced this shimmering sensation to his garden by planting airy white flowers liberally, such as white forget-me-not and white dame's rocket.

Single flowers (those with a single row of petals) like cosmos, also help to produce the Impressionist shimmer because when backlit by the sun the petals become transparent and shine like a Chinese lantern.

Although Monet used a lot of hybrids in his garden, and made special trips to nurseries in Holland and England for the latest varieties, he tempered their dominance by planting common wayside wildflowers among them, particularly red field poppies, wayside ox-eye daisies and purple foxgloves.

MONET'S TABLE ARRANGEMENTS

Towards the end of his life, Monet declared, "Flowers; I must have flowers, always." He wanted flowers in every room of his house, especially to decorate the dining room table. All of the Impressionist painters liked to paint floral still lifes. Because there were no books that taught concepts of flower arranging, the Impressionist painters made their own rules involving color, form and texture. Painting flowers was a way they could experiment with color and technique before attempting more complex compositions such as landscapes or portraits.

Monet especially liked flowers with fragrance. To ensure enough peonies in the spring for every room in his house, he even planted them as hedges around the plots in his vegetable garden. His tastes ran from simple bouquets involving one flower variety like yellow sunflowers or white clematis to elaborate arrangements involving different plant families.

THE WATER GARDEN

While the flower garden is composed of long straight lines that lead the eye out into the surrounding countryside, the water garden is designed for introspection. In Japan this design concept is known as a cup garden, the pond forming the bottom of the cup and the pond-side plantings its sides. Monet acquired this two-acre garden space after completing his flower garden, and it is much less formal in appearance. The emphasis here is on foliage colors, textures and shapes so that the water lilies on the surface of the pond become the main focus of attention.

The water garden features other elements of traditional Japanese gardens; for example, a high arched bridge with a canopy of wisteria was inspired by a Japanese woodblock painting that he owned, and there are a number of Japanese plants, such as bamboo, butterbur, hostas, Japanese iris, tree peonies, Japanese maples and weeping willows.

The Japanese bridge is on a direct alignment with Monet's Grande Allée and marks the start of a trail that follows the edge of the pond like those in Japanese stroll gardens. However, it is not a slavish copy of a Japanese garden. Rather, Monet used the Japanese design aesthetic for inspiration, reading about it in magazines and during discussions with his neighbor, American Impressionist painter Lila Cabot Perry, who had spent several years in Japan. The design is a Monet original, a blending of two cultures—Japanese and European.

Most important is the expanse of reflective water between the islands of water lilies. These became the subject of his final masterpiece, the water lily panels that today are housed in the Orangerie Museum, Paris, in two circular rooms.

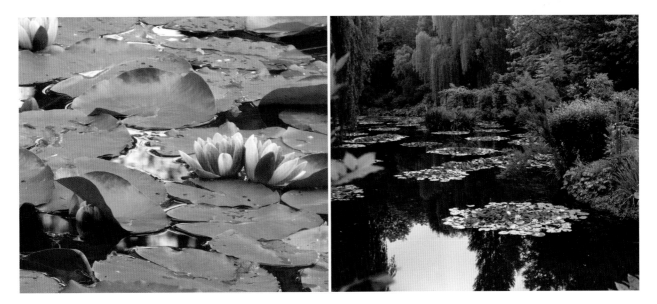

"We entered and my eyes widened in wonder . . . he had designed the water lily pond from the perspective of the path that encircles it, and each of the vantage points he had selected was enclosed in the framework of one of his canvases . . . the whole scene shimmered with the brilliance of an already fading sun whose last rays were resplendent as floods of gold in a pearl gray and turquoise sky."

—FRANÇOIS THIÉBAULT-SISSON,
"Claude Monet's Water Lilies,"
La Revue de l'Art Ancien et Moderne, June 1927

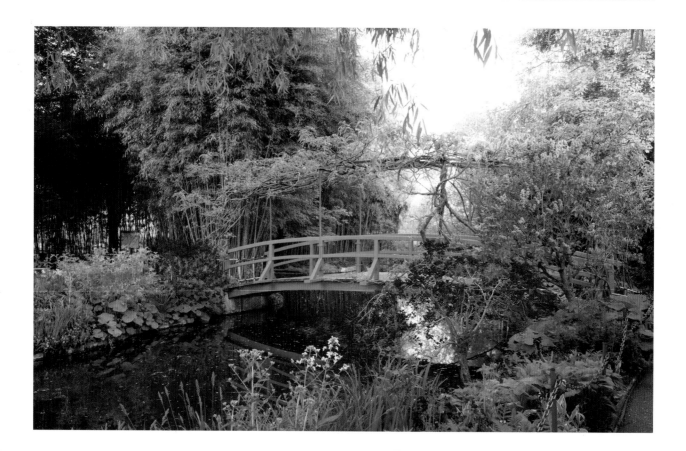

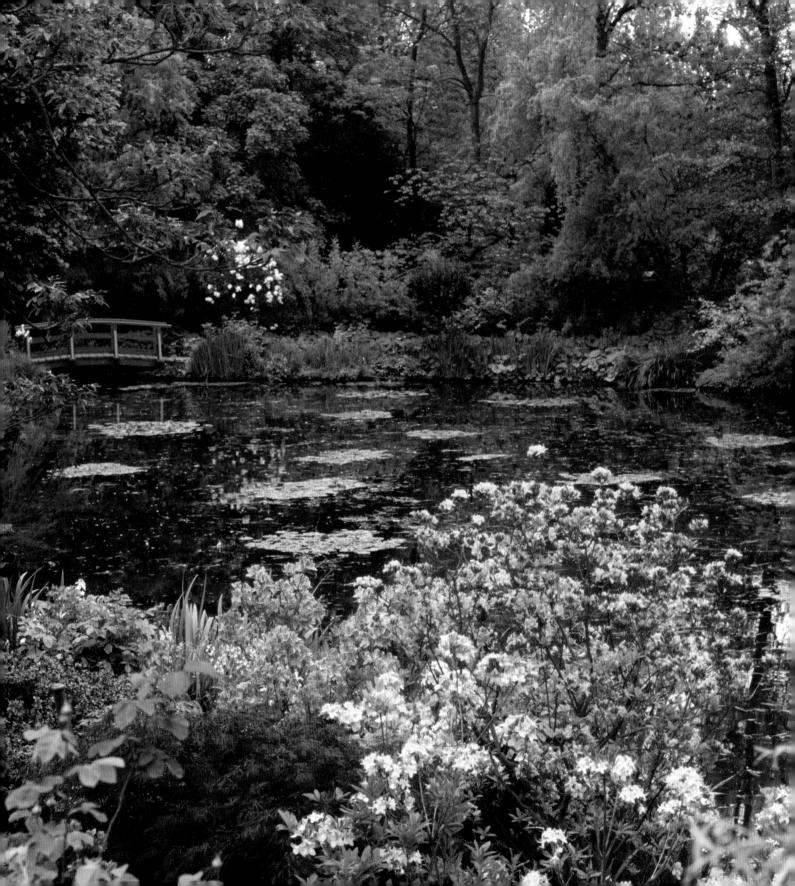

Monet's Kitchen Garden

MONET GREW A SELECTION OF VEGETABLES to one side of the flower garden when he first settled into the Pink House. These were in a small square plot enclosed by cordoned apple trees next to his poultry pens. As his paintings continued to sell well, Monet acquired a second property at the opposite end of the village. He painted the house blue and named it La Maison Bleue (the Blue House). There he could grow a much bigger selection of vegetables than he had room for at the Pink House. It was walled against intruders and had its own gardener, a young man known only as Florimond, who could borrow gardeners from the flower garden whenever he needed extra help.

Florimond took direction from Monet not only concerning what to plant but also as to what vegetables to supply for the family's meals each day—particularly for the pot au feu (see page 77), a type of hearty vegetable stew that was easy to prepare and serve in the evenings for such a large household, especially on Sunday. Monet always delighted at the arrival of the new season's vegetable seed catalogs. He would study the new varieties and decide what to order, notably selections from the Paris seed house of Vilmorin and also from foreign sources, such as Thompson & Morgan in England (a company that sold seeds to Charles Darwin). He would often order new varieties to evaluate against his traditional selections and invite comments from his family and friends.

Monet knew the value of rich soil as the foundation of good growth both for vegetables and for flowers. A visitor remembered seeing him in shirtsleeves on a summer's day, his hands and arms black with the compost he had been spreading. His friend Octave Mirbeau wrote him a letter about a planned visit to Giverny. It read, "I'm glad you'll bring Caillebotte. We'll talk gardening, since art and literature are nonsense. Earth is the only thing that matters. Even a clod of earth fills me with admiration, and I can spend hours staring at it . . ."

The kitchen garden was divided into plots for each family of vegetables: the cabbage family, which included hardy radishes, kale and turnips, in one area; legumes such as peas and beans in another; and tender vegetables like tomatoes, peppers, potatoes and eggplant in another. This arrangement allowed Florimond to practice crop rotation so that a plant family never occupied the same space two seasons in succession.

Florimond also used rows of glass-covered cold frames along the sunny side of the stone-walled enclosure to grow and harvest vegetables that required only frost exclusion, such as salad greens, e.g., 'Merveille de Quatre Saisons' head lettuce with red-tinted leaves and a buttery heart and 'Paresseux de Castillon' spinach.

"He has dared to create effects so true-to-life as to appear unreal,
but which charm us irresistibly, as does all truth revealed. Who inspired all this?
His flowers. Who was his teacher? His garden."

—ARSENE ALEXANDER,

Le Figaro, 1901

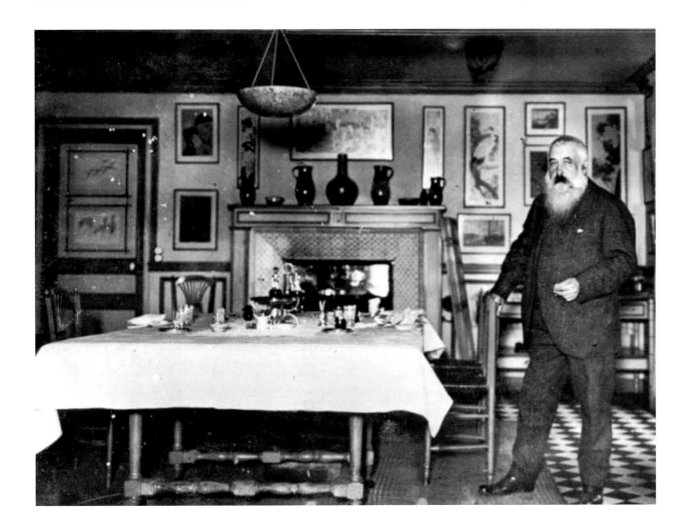

Cold frames extended the growing season for other hardy crops such as endive, beets, parsnips and carrots. Florimond had access to Monet's large greenhouse at the Pink House in which to start seeds. He also used the cold frames at the Pink House to harden off seedlings before placing them in their permanent positions. These included cucumbers for trellising and other summer treasures.

Monet was very fond of zucchini squash (also called *courgette*) and red cabbage. Florimond brought these to maturity extra early in the season, even before the last spring frost date, by growing them in the cold frames.

Since fruit trees can take up a lot of space, these were espaliered along the boundary wall, including 'Reine des Reinettes' russet apples (required for the famous Normandy apple *tarte Tatin*), 'Comice' pears and several varieties of peaches, plums and cherries. Trenches were dug and filled with sifted soil to accommodate carrots and asparagus roots. The asparagus were covered with a thick layer of shredded leaves in order to whiten the new stems and sweeten them as they emerged from winter dormancy. Stalks of celery were also blanched with shredded leaves piled up against the stems in order to tenderize and sweeten them. Rhubarb had a special bed to grow extra thick; Florimond delighted in forcing the succulent red stalks to the surface in early spring using special urn-shaped terra-cotta pots. Perennial 'Vert de Provence' artichokes also had a special plot to themselves, the bushy this-tle-like plants bearing round, succulent chokes by late summer.

Florimond grew an assortment of melons in the cold frames, while rows of other warm-season crops, such as tomatoes, needed covering with glass bell jars until all danger of frost had passed. Lines of glass cloches also protected tender seedlings such as cucumbers and bush snap beans, although he was always sure to grow ever-bearing pole beans, which were later to bear, for their superior flavor.

Many members of the onion family were grown from seed, including erect leeks with creamy white stalks, globe onions, white pearl onions (which made Monet's favorite pickles), garlic and shallots—to add a piquant flavor to malt vinegar. In summer, when the vegetable garden was at its peak, the whole area had the appearance of a patchwork quilt composed of feathery light green from carrots, yellow-green from endive, the dark-green of spinach, blue-green from spiky onion leaves, bronze-green from beet leaves and blocks of purple from red cabbages grown shoulder to shoulder.

At the end of June, Florimond would start to scratch the soil away from the roots of Irish potatoes in order to find small golf ball-size "new" potatoes to delight Monet ahead of the main late-summer harvest. Monet was among the first in the region to grow Chinese artichokes, a clover-like plant with small, nutty-flavored tubers, and he grew several varieties of white, black and red dessert grapes along wooden trellises. Florimond would wait until the first frost of

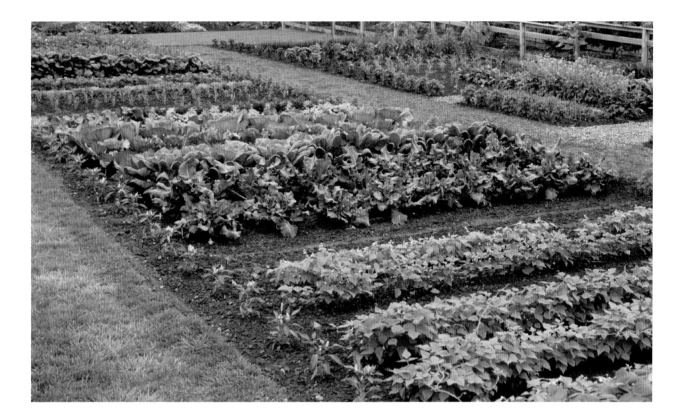

autumn to harvest Brussels sprouts and parsnips, for the cold improves their flavor.

Not an inch of space was wasted. The paths were just wide enough to accommodate a wheelbarrow. Hedges of perennial herbaceous peonies separating the plots supplied the house with fragrant arrangements in spring, supplementing those grown in the flower garden.

Even during trips away from Giverny, Monet expressed concerns about his kitchen garden, and he worried when Alice did not keep him informed. One particular letter, written on March 9, 1900, from the Savoy Hotel in London begins:

"My good darling, still no letter from you this morning. I hope that you found the house and garden as well as the greenhouse in good shape. It would be good that you keep an eye on it from time to time so that Pascal gets used to being watched a little; just the same it would be good to know what is going on at Florimond's garden; see if the vegetables are in good shape, know what is planted. Eugene is supposed to go twice a week. It would be necessary to find out and go the day that he is there . . . "

The letter is signed, "Your old man, Claude."

MONET'S FAVORITE VEGETABLES

To emulate Monet's kitchen garden, prepare a square plot and divide it into quadrants with intersecting grass or bricks paths. Plant the cabbage family in one quadrant, legumes such as peas and beans in another, members of the onion family in another, and warm-season plants such as tomatoes and peppers in the fourth. Add more squares for other families of crops if you need extra space. Edge the borders with culinary herbs such as parsley, which Monet liked chopped finely as a flavoring at almost every main course.

The following pages describe the vegetable and fruit varieties that Monet grew, or which have replaced varieties he would have grown whenever the original varieties are no longer in cultivation. Note the emphasis on varieties that display an unusual color. Monet was a colorist—considered by Cezanne as the best among his contemporaries—so he grew vegetables with unusual colors to satisfy his colorist's eye. The varieties were not only for still-life studies but also for making his food presentations more visually appealing.

In the following text, sources for the varieties named can be located through an Internet search by typing in the family name and variety name, such as Melon (family name) 'Early Frame Prescott' (variety name).

ARTICHOKE. Milder than asparagus in flavor, these tender perennial relatives of the thistle family are similar in texture to a tender boiled potato. 'Romanesco Purple' is a beautiful purple variety that produces succulent globe-shaped flower buds that become tender when steamed or boiled. The scaly flower buds are picked with ¹/₂ inch of stem attached, and after cooking the part of each scale where it is attached to the stem is eaten by scraping the scale between one's teeth, usually after dipping the edible part in parsley butter.

Monet also grew the Jerusalem artichoke, a type of perennial sunflower with an edible tuber, but it was more for ornamental value than for culinary use. For eating, he preferred the Chinese artichoke, a legume similar to clover that grows small, nut-like tubers in the soil, tasting of water chestnuts when cooked.

ASPARAGUS. Harvesting luscious, bright green asparagus spears is an age-old rite of spring in France. The emerging edible stems or spears are so tender that they may be eaten raw. 'Argenteuil' is a popular French heirloom variety; blanching sweetens the spears. Monet would have delighted in the newer 'Purple Passion,' variety, which is two weeks earlier than 'Argenteuil' and even more tender. Asparagus can be separated into males and females, and it is the males that bear the thickest, most succulent spears. The females are identified by red berries that ripen in summer.

BEANS. The terms *haricots verts* and *French filet* are names that apply to green snap beans, grown for slender, stringless, edible dark-green pods that are tender when steamed. Although butter is the perfect accompaniment to a side dish, some pole types—like the

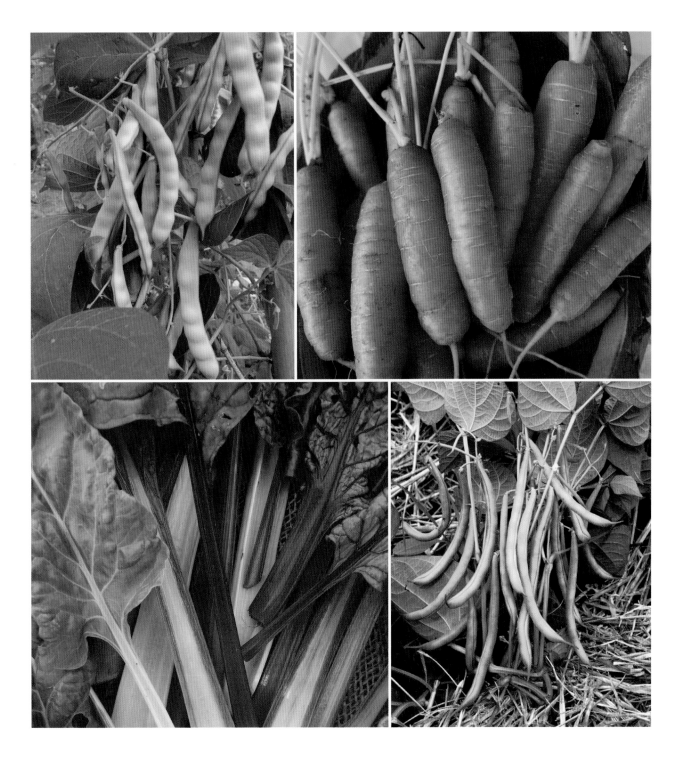

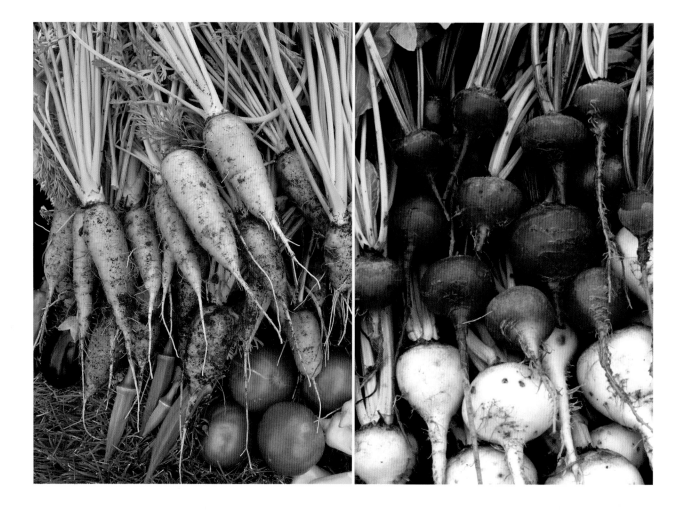

"I'm glad you'll bring Caillebotte. We'll talk gardening, since art and literature are nonsense. Earth is the only thing that matters. Even a clod of earth fills me with admiration, and I can spend hours staring at it . . . "

—OCTAVE MIRBEAU,

in a letter to Monet

'Lazy Wife' heirloom variety—have a built-in buttery flavor. The French filet variety 'Rolande' has extra-slim, long green beans. 'Roc d'Or' is a yellow-podded variety with long, round, buttery-flavored pods. Among pole beans, which Monet preferred for flavor and nonstop production, 'Emerete' is a classic French variety, producing long, slim, rounded, tender green beans on tall, vigorous vines that need staking. Although Monet grew bush bean varieties for earliness, these tend to stop bearing after several weeks, so Florimond grew an assortment of later-maturing pole snap beans for improved flavor, heavier yields and a considerably longer cropping period.

Another popular ever-bearing pole bean that Monet grew is the runner bean known as *haricots à rames*. Bearing scarlet flowers, these plants quickly turn into green, flat-podded beans up to 17 inches in length. Normandy's cool, cloudy, rainy summer climate is perfect for them.

Monet also grew two beans for shelling: lima beans and broad beans. His lima beans were mostly dwarf bush types, such as the large-seeded 'Fordhook Bush' or smaller-seeded 'Henderson's Bush.' Since pole limas require a long growing season, like that of speckled 'Christmas,' seed needs starting indoors to obtain three-week old transplants. Normandy grows excellent hardy broad beans. These are also known as fava beans, of which 'Giant Windsor' is a popular heirloom, growing enormous pods with five large, meaty beans per pod.

BEETS. The rich, dark purple color of a beet beads with moisture when cut, while cooking releases its succulent, almost honey-flavored sweetness. Indeed beets contain more sugar content than any other root vegetable. In Monet's day the choice among beets was limited to one color—dark purple, such as 'Detroit Dark Red.' Today the French grow both a flattened type called Egyptian and the rounded crapaudine varieties. Also, the color selection has expanded to include scarlet-skinned 'Chioggia,' with a white bull's-eye interior, and yellow 'Burpee's Golden.' In France, the mixture named 'Lollipop' contains the purple, red and yellow that would have commanded Monet's attention on account of the rich color range.

BROCCOLI. Famous for its sweet, tight-budded clusters, broccoli is most flavorful when picked before the head starts to yellow. The Italian heirloom 'De Cicco' was introduced into France and elsewhere in 1890. After the central head is cut, plants produce side shoots with smaller heads.

An heirloom vegetable related to broccoli that Monet may have encountered in Italy is 'Romanesco.' Grown as an autumn crop, it has a flavor more like cauliflower than broccoli and the most attractive head of any plant in the cabbage kingdom. These heads are conical, with tight green florets gathered in a spiral resembling a head of sea coral.

BRUSSELS SPROUTS. The edible green buds (or sprouts) of this hardy member of the cabbage family

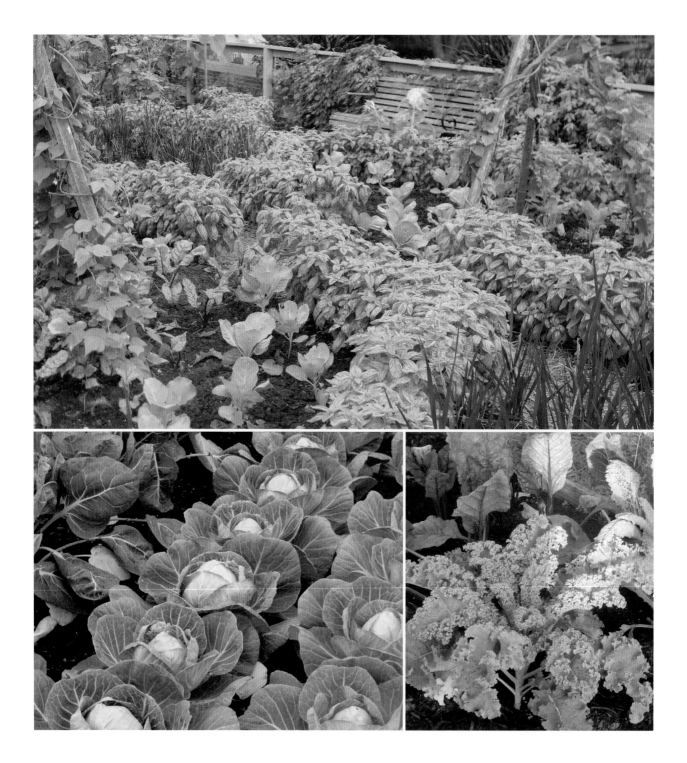

are sweet, with a mild cabbage flavor. Florimond knew that to generate the best flavor in Brussels sprouts he had to wait until after an autumn frost (usually early November) before picking them. Since mature plants can tolerate freezing, and even a covering of snow, Monet as able to include them in his Christmas dinner.

CABBAGE. Its leaves have a bittersweet flavor that becomes sweeter after cooking. The bitterness is less pronounced towards the heart. Like most artists (notably the Dutch masters who painted still-life arrangements featuring vegetables) Monet's favorite heading cabbage to paint was the handsome savoy type, with dark-green "blistered" leaves and a butter-yellow center. In France these are known as Milan cabbages, as opposed to the cabus (or smooth-headed family). Reflecting his interest in color, the red cabbage was Monet's favorite for pickles.

CARROTS. They have a sweet, refreshing flavor when eaten raw, cooked or juiced. It was Dutch seedsmen who bred the first garden-variety carrots from a wild species of Queen Anne's lace, but French seedsmen perfected them. They produced variously shaped orange-rooted varieties with French place names, such as the spike-shaped 'St. Valery' (dating to 1885) and stump-rooted 'Scarlet Nantes' (dating to the 1850s). The latter grows roots with parallel sides and a rounded tip. Not really red but rather a deep orange, 'Scarlet Nantes' is the favorite French carrot grown today. 'Baby Babette' is a finger-type carrot, with an even, cylindrical shape that is ideal for snacking.

CAULIFLOWER. Related to broccoli, and a member of the cabbage family, cauliflower grows a head of tightly packed bud clusters called florets that impart a crunchy, almost nutty sweetness. Cauliflower requires a cool growing season. The white head (known as a "curd") must be protected to maintain a crisp, clean, white color. This is done by folding the long, ribbon-like wrap leaves over the immature head and tying with a rubber band to exclude light.

CELERY. A staple of almost every French kitchen, including Monet's, the edible stalks of celery have a mild flavor served cooked or raw. The French like their celery stalks blanched. Although this reduces its nutritional value, it sweetens the flavor. Blanching is done after the plants have matured, by heaping leaves against them up to the first crown of leaves. This excludes light and turns the stalks white.

There are pink-stalked celeries that Monet may have grown for their novelty, and he may have grown a self-blanching variety as well. With self-blanching celeries, the outer stalks are pale green and so tightly packed together that they exclude light from the inner stalks, which turn white or pale yellow without blanching.

Monet would have also grown turnip-rooted celery, or celeriac, a delicious root vegetable. In appearance, celeriac resembles celery with erect stalks, but

where the stalks meet the soil, the root swells to the size of a baseball. Peeled, cooked and mashed like potatoes, it makes a delicious side dish.

CHARD. A robust, leafy green vegetable, chard has a crisp, succulent mid-rib as crisp and juicy as a stem of bok choy Chinese cabbage. The stalks are braised like celery and the crinkled green leaves can be used as a spinach substitute. 'Ruby' is a crimson-stalked variety that Monet might have grown, considering his liking for vegetables with bright colors. Today, however, the one to grow is 'Bright Lights' because it has 11 distinct stalk colors, including orange, yellow, lemon, pink, apricot, red and white, and bi-colors. Sauté the leaves and sliced stalks with butter and sprigs of rosemary; it makes a delicious flavor combination.

CUCUMBER. With an incomparable clean, moist flavor and a crisp, cool sweetness, cucumbers are refreshing. 'Paris Pickling,' also known as 'Improved Bourbonne,' is a French heirloom dating to the late 1800s. It produces heavy yields of small, crisp cornichon-type cucumbers, a favorite for pickling. Monet liked pickles, especially for his picnic meals. Among slicing cucumbers today, Monet doubtless would have grown the 'Burpless' varieties. With such a sweetly flavored, tender skin, the fruits require no peeling. An heirloom that Monet might have grown for its attractive shape and color is the 'Lemon' variety, which forms a round yellow ball and looks attractive in a cornucopia of mixed vegetables.

DANDELION LEAVES. French chefs cherish these as the most desirable of all salad greens because of their mild, nutty, bittersweet flavor. Dandelion salads served in French restaurants today, usually enhanced with crumbled bacon, generally command the highest prices among salad dishes. A cultivated variety has been developed from the wild dandelion seen in weedy lawns.

EGGPLANT. This late-summer treasure is a mild-flavored vegetable that has a creamy white flesh and is often used as a substitute for meat in vegetarian dishes. Called *aubergine* in France, the most popular eggplant grown in home gardens during Monet's time was the classic bulbous Italian type, rather than the slender Asian type. Monet undoubtedly also grew a white-and-purple-striped variety, 'Listada de Gandia,' introduced to France in 1850. It is similar in appearance to the modern variety 'Purple Rain,' which is twice the size. These are generally sliced into $1/2$-inch-thick wheels, covered in breadcrumbs and grated cheese, and either sautéed or grilled with seasonings such as rosemary and sage to improve the rather bland flavor.

Once an eggplant is sliced open, the interior turns a rusty brown color like a sliced apple. The discoloration does not affect flavor, but it can be delayed by squeezing lemon juice over the slices.

ENDIVE. Best described as a lettuce with a hint of bitter flavor, this attractive salad green develops a

rosette of finely cut curled leaves and a heart that is sweet and butter yellow.

FENNEL. The French hybrid variety 'Trieste' grows large, rounded, thick stem clusters composed of scales that taste like licorice and are crispy when eaten raw. The scales can be sliced into scoops for dipping or steamed as a side dish. There are actually two kinds of fennel that Monet would have grown—the non-bulbing variety that is mostly grown for its feathery, aromatic leaves and used as a garnish, and the bulbing kind known as Florence fennel.

FIGS. Is there anything in the fruit kingdom more succulent and delicious than a tree-ripened fig? Monet espaliered figs up the wall of his kitchen garden. By providing them with warm stones to grow against and shelter from winds he could leave his fig vines outside all season, especially by growing a hardy variety like 'Brown Turkey,' which produces chocolate-skinned fruits and soft, sweet crimson centers. 'Saint Michael' variety is similar to the famous yellow 'Mission' figs grown in Southern California.

GRAPES. Monet grew sweet dessert grapes for eating off the vine rather than wine grapes, because he liked the vine-ripened sweetness of dessert grapes and Normandy is not a good climate for quality wine grapes. Bunches of red, black and white varieties are featured in several paintings he produced, including *Still Life with Peaches, Melon and Grapes*. A small section of grape trellis still survives at the Blue House, where he grew grapes in his kitchen garden.

HERBS. Judging from his cookery journals, Monet's favorite herbs were parsley and chives to flavor everything from fish dishes to vegetable dishes, soups and stews. Herbs in general come from parts of the Mediterranean with poor soils, where Monet painted, and they tend to be easy to grow.

Culinary herbs can make such a huge difference to the flavor of a dish that Monet grew them as an edging to his vegetable plots. In France, the term *bouquet garni* describes a cluster of several herbs, usually parsley, rosemary and thyme, although it may also include chervil and chives and other culinary herbs, depending on the recipe. These were either tied together in clusters and steeped in a soup or stew to improve its flavor, or chopped fine and tied in cheesecloth to suspend in the pot, the idea being to not overpower the other ingredients but merely enhance their flavor. The French term *fines herbes* refers to a mixture of equal parts finely chopped chervil, chives, parsley and tarragon. These are added in the final cooking stages to sauces, soups, cheese dishes and egg dishes.

Basil has a sweet, anise-like flavor. A tender annual, there are many different kinds. It enhances the flavor of tomatoes. There are many different kinds, including the regular 'Lettuce-leaf,' which has spear-shaped shiny leaves, 'Green Mound,' which resembles a miniature boxwood plant, and 'Siam Queen,' which has a bronze leaf and beautiful pink flower clusters.

POTAGER

The *potager* in France refers to a kitchen garden that grows mostly edible crops such as vegetables, herbs and fruits, and also may include flowers for cutting or edible flowers for decorating meals, such as nasturtiums (used to add a peppery hint to salad) and calendula (used to add a pleasant bitter-sweet flavor to salads). There is no particular design for a potager except that the French generally like them to be formal in design, with geometric plots separated by low, clipped boxwood hedges or low woven wattle dividers. The best potagers use colors of the vegetables for decoration—for example, a block of green head lettuce contrasting with a block of purple cabbage. The textures and leaf shapes of plants also provide striking contrasts—for example, the bushy, dark-green compound leaves of potatoes next to rows of spiky blue-green leeks.

Favorite flowers for cutting include long-stemmed asters, cosmos and dahlias and spires of gladiolus and larkspur. A potager always includes a neat compost pile, where kitchen and garden waste is allowed to rot down to make nutritious compost, and decorative vertical accents upon which vining crops can climb. Obelisks, for example, make decorative supports for cucumbers, while an arbor in the center of the *potager* can be planted with pole snap beans. Bamboo trellis and bamboo stakes are also favored for supporting climbers, which is why many French *potagers* feature a decorative grove of bamboo to do double duty as a privacy screen. Monet's bamboo grove is located beside his bridge in the water garden.

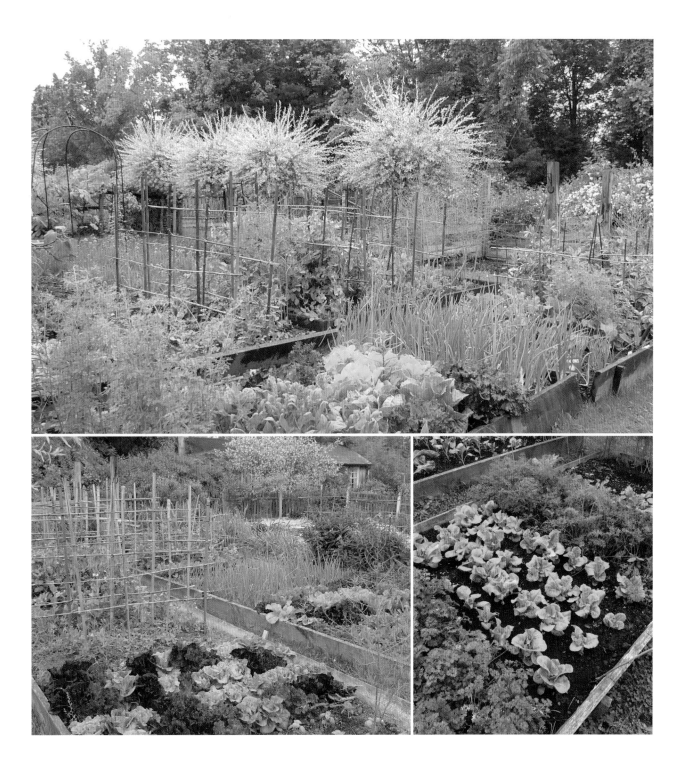

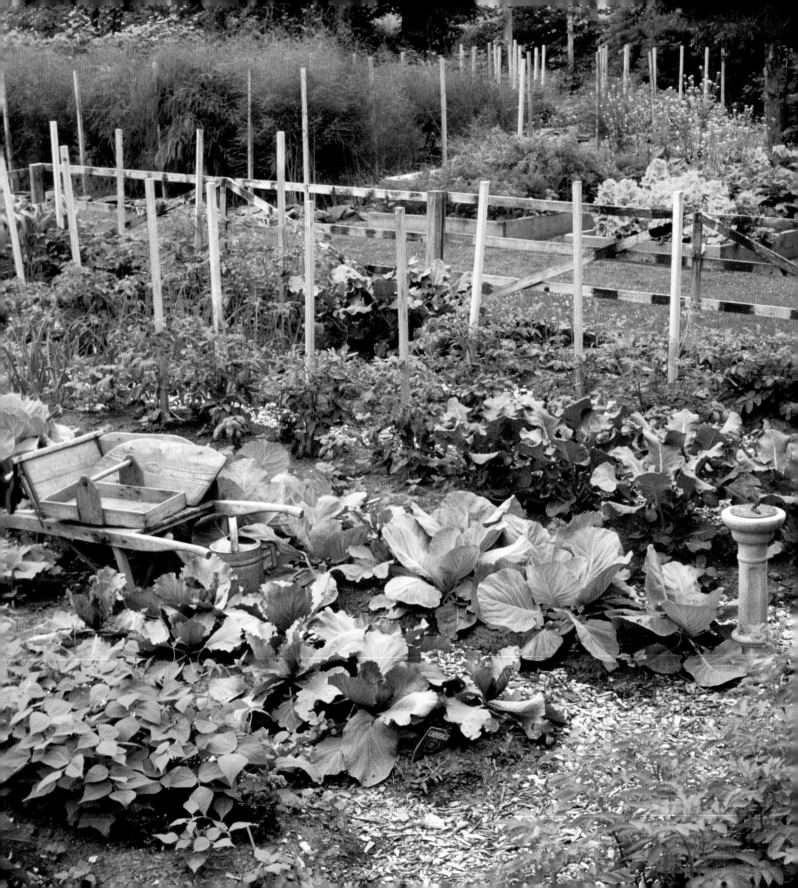

Chervil adds a mild parsley flavor as a garnish, and its delicate leaf pattern is attractive. A hardy annual, it is best direct seeded several weeks before the last frost date. The variety 'French Fancy' has finely cut foliage for flavoring soups, stews and mixed salads.

Chives are hardy perennials that produce slender, hollow, onion-flavored leaves and beautiful ball-shaped pink flower heads. The leaves are usually chopped fine to add flavor to numerous foods, especially soups and egg dishes.

Cilantro, also known as coriander, has a delicate lemony taste that is used to flavor many vegetable dishes. A hardy annual, it is similar in appearance to chervil, making it an attractive garnish.

Dill is an essential flavoring with feathery leaves that enhance fish dishes, imparting a flavor similar to fennel. Dill seed is also used to flavor cooked cabbage and cucumber pickles.

Garlic is a type of onion that can vary in strength of flavor, depending on variety. It is a hardy biennial grown from cloves that are shaped like small orange wedges to form an aromatic bulb. Usually the cloves are peeled of their papery skin and thinly sliced so they melt into the cooking but impart a pleasant onion flavor.

Mint would have been grown in a special raised bed to prevent its aggressive roots spreading into unwanted areas. Monet would have used mint as a decorative garnish to melon, and if he had the sniffles he might have had Marguerite brew a cup of mint tea to relieve his sinuses. The two popular varieties used to make mint sauce for enhancing the flavor of lamb dishes are spearmint (with a broad, velvet-like, serrated leaf) and peppermint (with a more pointed, shiny, serrated leaf).

Parsley is the king of garnishes, usually chopped fine to add a celery-like flavor and bright green color to many dishes. 'Triple Moss Curled' is grown as a hardy annual. There is also a flat-leaf variety, 'Italian Flat-Leaf,' that many gourmet cooks prefer. Always harvest from the edges of the plant so new shoots grow from the middle.

Rosemary is an aromatic evergreen with needle-like foliage and a pleasant aroma similar to thyme. It is valued for flavoring many kinds of meats, especially lamb, and also egg dishes. There are several popular varieties, including a weeping form that can cascade over retaining walls and upright kinds suitable for growing in a container. Both produce attractive blue flowers in summer.

Sage leaves are 'blistered' like a savoy cabbage and taste like thyme. Sage is considered essential to any type of poultry dish, especially stuffing. It is also used in bouquets garnis to flavor soups and stews.

Tarragon has a faintly anise flavor and used for flavoring soups, stews and sauces. It is a hardy perennial, but be sure to choose French rather than Russian tarragon.

Thyme has small leaves with a sage-like flavor suited to soups and stews and poultry stuffing.

KALE. The shiny, dark-green leaves of kale have a strong cabbage-like flavor, and because of its nutri-

tional qualities, it has become a popular ingredient in salads and soups and for juicing. Known as *chou frisé* in France and borecole in England, kale varieties often occupied two pages in seed catalogs during Monet's life. The plant fell out of favor after World War II with the general decline in the number of kitchen gardens, and only recently has its popularity been revived through the discovery of new ways to enjoy it, from blending it into smoothies to producing crispy kale chips seasoned with grated cheese and herbs.

LEEK. Similar in flavor to onions, but with a distinctly sweeter taste and a more succulent texture, leeks display long white stalks and a fan of flat, edible strap-like leaves. Few French kitchen gardens, or *potagers*, are without a block planting of leeks because French cooks like to use this onion relative in myriad ways, notably in soups and stews, flavoring a dish without overpowering it. 'Bleue de Solaise' is a French heirloom dating to the 1800s. It is still the leek that most French gardeners grow today because it grows tall, thick, erect white stalks.

LETTUCE. The French heirloom variety 'Merveille des Quatre Saisons,' translating as 'Marvel of Four Seasons,' is a butter-head lettuce that has red-tinted wrap leaves and a red-tinted head that is crisp, sweet and crunchy on the inside. Introduced by Vilmorin in 1885, the heart is a buttery yellow like an American Bibb lettuce.

There are two other kinds of lettuce that Monet would have grown. They are generally referred to as "loose-leaf" and "cos." The loose-leaf kinds do not form heads but a loose rosette of leaves. Cos types grow tall, with a crisp central rib to each leaf, and they form a loose, crispy head.

Among several kinds of loose-leaf lettuce Monet is sure to have grown is the 'Oak Leaf' variety, since it is early to mature and the scalloped shape of the leaf is highly attractive. Today, plant breeders have produced a large array of colorful lettuce varieties, including the 'Red Sails' loose-leaf type, 'Ruby' cos type and freckled 'Speckled Trout.' Plant in blocks of 6 to 8 plants in alternating colors for a beautiful patchwork effect.

MELON. The ripe flesh of a melon can vary in sweetness from one variety to another, some with a honey-sweet flavor and others with sweet citrus overtones. Monet grew several kinds of French melons and immortalized one of his favorite cantaloupe varieties in his painting titled *Still Life with Melon*. Called 'Early Frame Prescott,' and also known as 'Paris Favorite,' it was one of a series of 'Prescott' melons named for an Englishman and first introduced by the French seed house of Vilmorin in 1883.

The most popular melon variety in France today is the small, single-serving cantaloupe melon known as 'Charentais,' which originated in the Poitou-Charentes region of France in 1920, six years before Monet's death. The size of a large grapefruit, it is ribbed like a cantaloupe, is orange inside like a cantaloupe, and has

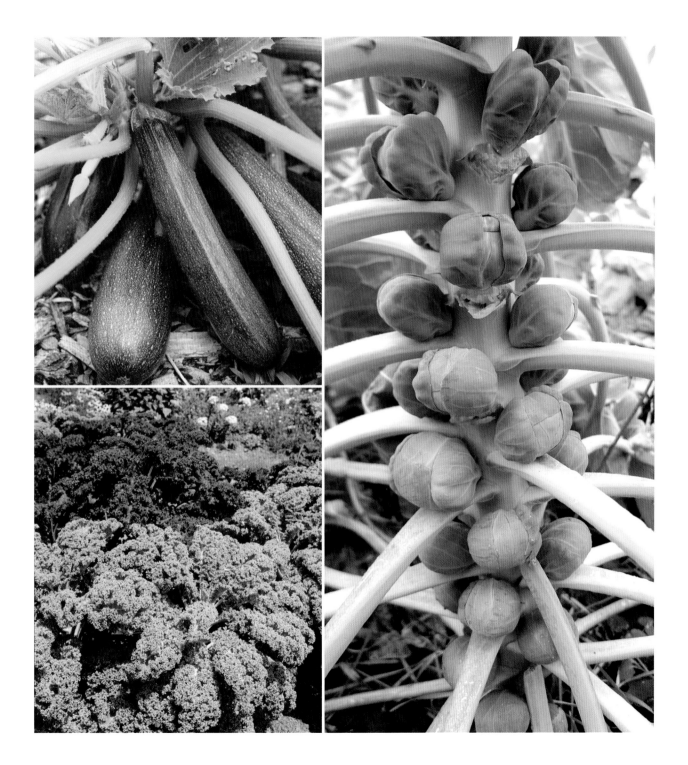

a highly perfumed flesh. Its honey-sweet flavor is at its peak when the rind has turned a golden color and the ribs are still green. In Paris restaurants it is often served cut into crescents and served with paper-thin slices of prosciutto ham and a pinch of grated nutmeg. A green-fleshed version, 'Ha-ogen' is equally delicious.

MESCLUN. In Provence, the word *mesclun* is a colloquialism meaning "mixture," and this mix of mini greens can consist of a variety of salad greens, from lettuce, mustard, kale, chard, arugula (*roquette* in French) and Asian greens to produce a combination of sweet and bitter flavors. 'Cut and Come Again' is a mesclun mix that the more you cut the more they form tender young leaves.

ONIONS. There is hardly a cooked main dish that is not improved by the addition of onions, which can vary in flavor from pungent to sweet in both their raw and cooked form. Normandy has a perfect climate for growing onions because of its ample spring and summer rainfall. They are mostly grown to produce round bulbs up to the size of a baseball, with yellow, brown, white or red skins, depending on variety. The flavor of onions varies according to variety as well. Onions that store well for long periods usually have the strongest flavor, such as the brown-skinned, white fleshed 'Southport Globe' or 'Ailsa Craig.' The sweetest onions, such as 'Giant Walla Walla' and 'Candy,' are best eaten as soon as possible after harvesting. Monet also grew the tiny marble-size pearl onions for

pickling. Although onion varieties can be regional in their performance, the foregoing varieties are suitable for all regions.

SHALLOT. This is a type of small onion whose flavor is often described as a combination of onion and garlic. In France, if you ask for vinegar, it will arrive in a small bowl with finely chopped shallot to enhance its flavor. Usually shaped like a teardrop, with brown skin, it can also be round. Shallot vinaigrettes using malt, apple or wine vinegar add a piquant flavor to most meat and vegetable dishes. Monet would have grown several kinds, including the French heirloom variety 'Zebrune,' also known as 'Cuisse de Poulet du Poitou,' which means "leg of a Poitou chicken." The torpedo-shaped bulbs are a beautiful pink and have a sharp onion bite.

ORCHARD FRUITS. In Normandy fruit trees such as apple, pear, peach, apricot, cherry, plum and fig yield mouthwatering flavors from fruits eaten fresh or stewed. Since fruit trees can take up a large amount of space, Monet grew these orchard fruits espaliered (flattened) against the wall enclosing his kitchen garden.

An example of espalier can be seen today in the flower garden at the main house, where pear trees are grown flat against sections of wall up a green trellis that forms a diamond pattern. Apples are trained to grow as cordons (ropes) bordering a square patch of lawn that used to be planted with vegetables before Monet acquired the Blue House property. All these fruiting trees have pliable branches that can be trained to

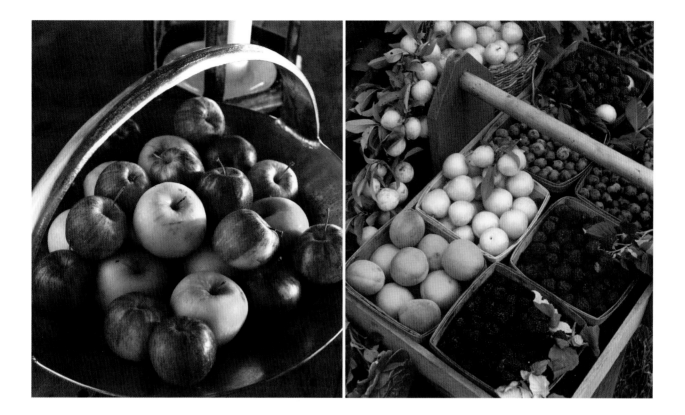

create patterns, such as horizontal or vertical parallel lines or splaying like a fan, for the reflected sunlight and heat from the wall to promote early ripening and heavy yields.

Heirloom varieties of French orchard fruits are difficult to acquire outside of France, but 'Reine des Reinettes,' also called 'King of the Pippins,' is a red-skinned, medium-size russet-type **apple** that Monet grew. It has a delicious tart-sweet flavor similar to a modern 'Gala.' His favorite **pears** were the yellow-skinned 'Beurre d'Hardemport' (similar to an American 'Bartlett') and the russet-skinned 'Doyenne de Comice' (similar to the American 'Conference'

pear), all of which are dessert-quality French pears good for eating out of hand.

The **'Prune' plum** (also known as 'Italian' plum) is a favorite throughout France, and though Monet's favorite peach known as 'La Peche de la Vigne' (the 'vineyard peach') is scarce, the early maturing white-fleshed peach called 'Spring Snow' has a similar maroon skin and a chin-dripping sweet flavor.

Apricots are closely related to peaches but tend to bloom earlier and therefore the flowers are susceptible to frost damage before they can set fruit. Growing them against a wall, as Monet did, improves the chances of warding off frost damage.

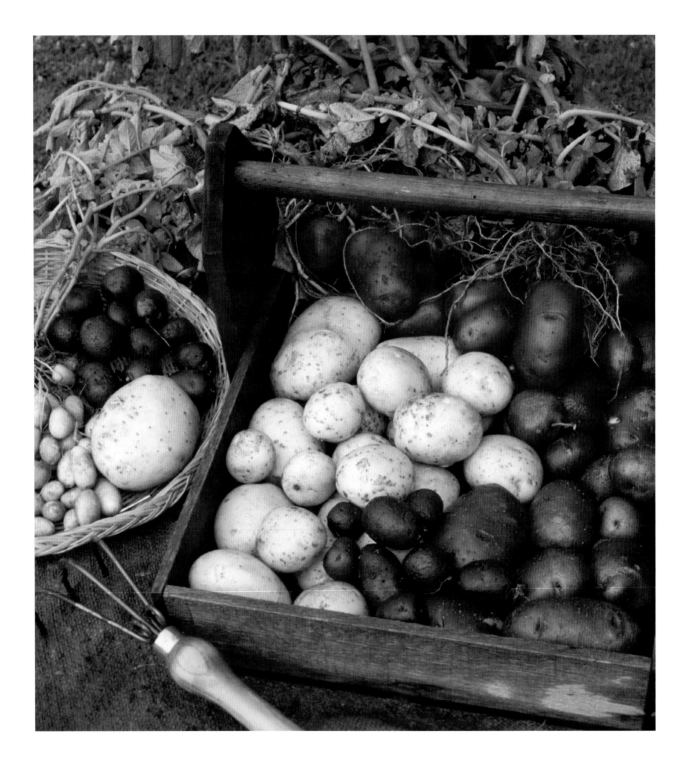

Monet planted three 'Montmorency' **red cherry** trees for the fruits to be preserved in brandy and to eat fresh. He was so fond of brandied fruits that he maintained barrels of brandy in his cellar at the Pink House. Another deliciously sweet cherry popular throughout France is 'Napoleon,' a large yellow cherry with a pink blush.

PARSNIPS. These hardy root vegetables have an even sweeter flavor than carrots, with a pleasant parsley-like flavor. Before Dutch plant breeders developed carrots from a wild species of Queen Ann's lace, the parsnip was Europe's favorite root crop because it stores well over winter. The flavor is improved after frost, so Monet grew it as an autumn crop.

PEAS. The pea variety known as petit pois is a generic name for a shell pea that produces small, dark-green pods and extra-sweet, bright-green peas. Petits pois are a favorite among the French to eat raw and steamed as a vegetable side dish.

The French call Chinese sugar pod peas *mangetout,* meaning "eat-all," although the flat pods must be picked before the peas inside swell the pod. Once the peas swell, the pod becomes fibrous. Today, the most popular pea is the 'Sugar Snap,' which has tender edible peas and also edible pods.

Peas like cool growing conditions. Normandy has such a perfect mild summer climate for growing peas that hundreds of acres are grow on farms surrounding Giverny. Where summers are hot, the vines will stop bearing and wilt by the beginning of summer.

POTATOES. The flavor of a potato will depend on the variety grown and when it is harvested. The French are particularly fond of white-skinned new potatoes harvested when the size of a golf ball. 'Belle de Fontenay' is a popular variety for fries, but the fingerling potato known as 'La Ratte' is what most French chefs prefer to use for potato salad because of its tender, creamy texture when cooked. Although potatoes are not expensive to buy at the market, many kitchen gardens throughout France will include a patch of potatoes if they grow nothing else that is edible. Each district has its favorite potato varieties. 'Burbank Russet' is popular because it makes such good *pommes frites* (French fries). 'Red Pontiac' (discovered in Florida), yellow 'Yukon Gold' (bred in Canada) and 'All Blue' (a blue-skinned and blue-fleshed variety from Peru) are all varieties that can help make a harvest of garden-fresh potatoes extremely colorful.

Harvesting generally occurs in late summer after the vines die down, although tasty baby 'new' potatoes can be plucked from the soil by mid-summer simply by scratching the soil surface and looking for tubers among the surface roots.

SWEET POTATOES. These are not an easy crop to grow in Normandy because sweet potatoes like long, hot summers to mature their edible roots. However, it is likely that Monet grew them in his cold frames, since he scoured both French and foreign seed catalogs

for anything novel to grow. Although orange-fleshed 'Beauregard' is the favored variety today, there are white-, yellow- and even maroon-skinned varieties.

PEPPERS, SWEET & HOT. Sweet bell peppers are mostly blocky in shape, with a crunchy skin that can be eaten raw. The French like to use them for stuffing with chopped meat, onions, parsley and cheese. They also use roasted peppers as a side dish and chopped raw into salads. In Monet's day, the sweet bell peppers were mostly green, ripening to red, but today sweet bell peppers can be yellow, cream-colored, purple, black and orange before turning red. Although these colors are grown on separate plants, the variety 'Gypsy' produces several colors on the same plant, including red, yellow and orange.

Monet also grew the hot 'Cayenne,' or chili pepper, to use as a flavoring for a dish called pepper pot stew.

PUMPKIN. The flavor of pumpkin improves with cooking. The variety 'Rouge Vif d'Etampes,' meaning "Vivid Red from Etampes," is also known as the 'Cinderella' pumpkin because of its flattened, ribbed, round shape. Introduced by Vilmorin in 1883, the yellow flesh is delicious for pumpkin soup and pie filling. The heirloom, 'Musqué de Provence' is similar but with beige skin.

RADISHES. These must be grown quickly during cool weather to keep them crisp, crunchy and sweetly flavored, with a hint of piquancy. Radishes today come in many shapes—including round, oblong, and icicle—and colors—red, purple, gold and white. But it is the bi-colored variety 'French Breakfast' that the French prefer above all others. For the best flavor, radishes must receive regular amounts of moisture to keep them growing, as any arrest in their development will generally produce bitter flavors and distorted roots. Mixtures of the different skin colors are now available. A popular mixture where equal quantities of colors have been blended is 'Easter Egg.'

RHUBARB. Monet liked rhubarb pie, and though rhubarb is sufficiently hardy to be grown without protection, he would have grown a sizable clump of it in cold frames so Florimond could harvest the edible red stalks extra early in the season. Although the stalks of rhubarb are super tart and fibrous, cooking tenderizes them. Chopped into 1-inch segments, and with the addition of a sweetener, rhubarb is transformed into a delectable pie filling or compote.

Be aware that the large, ruffled green leaves are poisonous and only the stalks should be used. To prepare them for cooking, chop off the green part of the leaf. As a pie filling, rhubarb can be used alone or combined with strawberries, for a truly delicious flavor sensation.

SPINACH. Monet liked spinach, not only raw as a tasty salad green but lightly steamed as a side dish. The smooth, dark, jade-green leaves are succulent

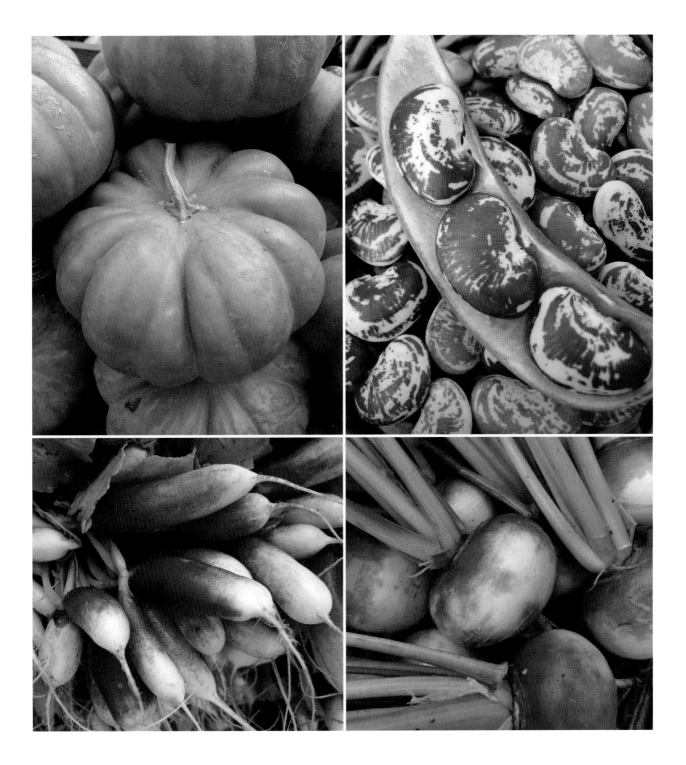

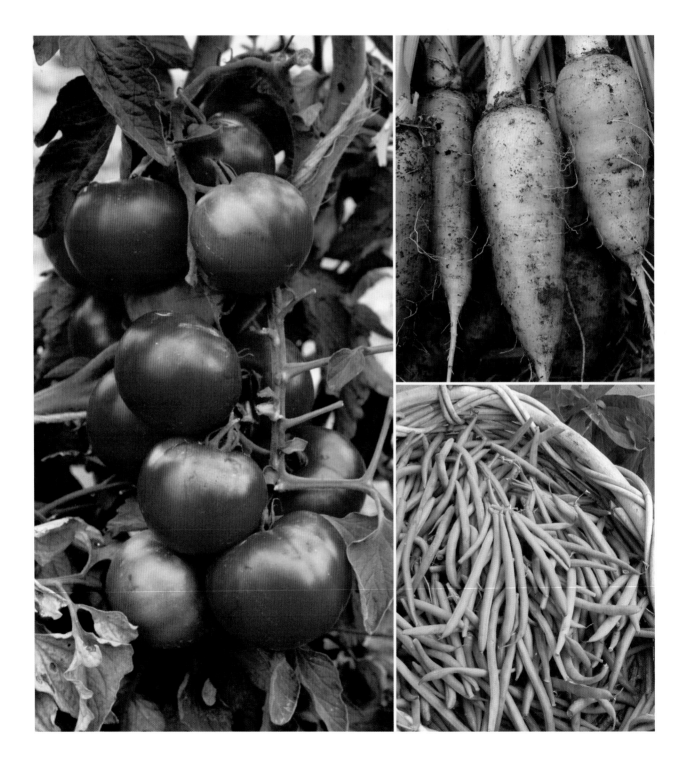

and delicious, but they must be harvested during cool weather; otherwise the plants quickly bolt to seed.

Since Normandy can experience cool summers, Florimond would have undoubtedly made succession sowings, even through the summer months. For those who garden where summers are hot and humid, such as North America, a good substitute for French spinach is Malabar spinach, from India. It thrives during hot weather.

SQUASH, SUMMER. Unlike winter squash, summer squash fruits can be eaten raw when young, including the skin, seeds and interior flesh. They have a far more delicate flavor than winter squash. The three most popular kinds of summer squash are green zucchini, yellow patty pan and yellow crookneck. Monet grew the French heirloom zucchini squash known as 'Ronde de Nice,' a plant that produces round green fruits the size of a softball and that is enjoyed stuffed. The skin is tender and the interior white flesh has a subtle flavor. It is generally sliced to eat raw in salads or steamed as a cooked vegetable. In order to get an early harvest, Monet grew zucchini squash plants in cold frames, closing the hinged glass tops whenever a period of cold temperatures occurred.

SQUASH, WINTER. The flesh of winter squashes is orange or yellow and similar in flavor to a sweet potato. Winter squashes differ from summer squashes by maturing at the end of summer. They have hard skins that enable them to be stored for several months and a firm interior flesh that is rendered tender by cooking. Although today the two most popular winter squashes are the green-skinned acorn and the beige butternut, Monet would have grown the French heirloom 'Musquée de Provence,' also known as 'Potiron Bronze de Montlhéry.' Weighing up to 20 pounds each and sometimes listed under pumpkins in seed catalogs, they are a handsome beige color and heavily ribbed. Today, 'Royal Acorn' is a fine-flavored acorn-type squash, while 'Waltham Butternut' is considered the best of the butternut varieties for large size and good flavor.

STRAWBERRIES AND OTHER SOFT FRUITS. During Monet's lifetime, the French grew two kinds of **strawberries**: June-bearers, which are large-fruited and crop for several weeks in June, and smaller *fraises des bois* (or woodland strawberries), which grow wild in Normandy. Today, plant breeders have produced new varieties of large-fruited strawberries that can be classified as everbearing and day-neutral. The everbearings crop in June during cool weather and again in fall at the return of cool conditions. The day-neutrals crop several times a year, even in mid-summer, because their flowering and fruiting is unaffected by day length, as with other strawberries. For maximum sweetness, pick only those that are completely red. Today a day-neutral variety called 'Albion' is popular with home gardeners.

Monet also grew other kinds of soft fruit, notably **raspberries, blackberries, gooseberries** and three kinds of **currants**—white, black and red. These were

used not only for fruit salads and toppings to dessert dishes but also to make jams and pie fillings. Black currants in particular make a delicious fruit wine.

Although blackberries grow wild throughout Normandy and Monet's sons enjoyed gathering these when they ripened in summer, Monet would have grown the earlier-maturing, larger-fruited cultivated varieties. Today, gardeners can choose thorn-free kinds like 'Chester' and 'Hull.' To ensure sweetest flavor, do not pick the berry unless it falls easily into the hand. Even when black, indicating perfect ripeness, a blackberry may need several more days before it loses its tartness.

Raspberry breeding has come a long way since Monet's day, notably for fruit size and heavier cropping ability. The dusky red variety 'Titan' is the size of a small strawberry, maturing in mid-summer, while bright red 'Heritage' crops twice a season.

Although they were not yet introduced to the West from China until after Monet died, the gardeners at Monet's garden today decided that he would most certainly have grown **kiwi** fruit. Since they produce attractive flowers resembling clematis, they have been added to the flower garden. The brown, fuzzy fruits are grown on vigorous vines along the top of the walled enclosure that runs beside the greenhouse. Normally too tender for Normandy's climate, the roots are sufficiently sheltered by the wall to be protected from freezing.

SWEET CORN.
Kernels of sweet corn contain a milky fluid that is sugary sweet when the silks have turned dark brown. Since sweet corn prefers high heat and plenty of sun, and Normandy can experience cool summers, Monet would have started his sweet corn in cold frames. When the stalks reached the glass covering, the glass was removed permanently.

In Monet's day the favorite variety was an American yellow corn, 'Golden Bantam.' Since it is not a hybrid, in order to retain its flavor, the cobs of 'Golden Bantam' should be cooked in boiling water as soon as possible after they are picked; otherwise the cobs quickly convert their sugars to starch. Today, white sweet corns are generally preferred over yellow sweet corns, especially the variety 'Silver Queen' and the earlier maturing, bi-colored 'Honey and Pearls.'

TOMATO.
If Monet had had room for only one vegetable in his kitchen garden, he would probably have selected the tomato, a vegetable fruit whose juicy, sweet flavor is affected by choice of variety, time of picking and the amount of sunlight it receives. Monet grew both cherry-size tomatoes and large kinds. Since Normandy generally experiences cool summers Monet would have started some of his tomato plants in cold frames. 'Marmande' is a French heirloom that is slightly ribbed and capable of growing to the size of a 'Beefsteak' tomato. It is scarlet-red and richly flavored, suitable for eating raw in salads and cooking. Cherry tomatoes fruit earlier and are capable of producing hundreds of sweet fruits, either round like a cherry or pear-shaped. His choice today would surely be the orange-fruited 'Sun-Gold' that is as sweet as candy.

These are perfect for taking on a picnic for snacking. For tomato sauce he would have grown an Italian paste tomato such as 'Roma,' with oval or plum-shaped fruits, since they make the best tomato sauce.

Since Monet's day the color range of tomatoes has been extended. In addition to the common red there are yellow, orange, pink, maroon and purple plus striped varieties like 'Green Zebra' and 'Big Rainbow.' When all these colors are arranged in a bowl or basket the effect is beautiful, worthy of a still-life painting.

TURNIPS. These have the texture of a potato and the flavor of mustard greens, although newer vari- eties can be extremely sweet when cooked. They are a regular accompaniment to several dishes among Monet's favorite recipes. 'Purple-top Globe' has the appealing color combination of a purple top and white underside. Also, the leaves make a good substi- tute for cooked spinach. Even more sweetly flavored are several Japanese turnips, such as 'Tokyo Cross,' a small, round white variety that can almost melt in your mouth after it is steamed.

MONET'S GARDEN PREFERENCES
Choice of Seeds

The term *heirloom* has such a strong attraction among

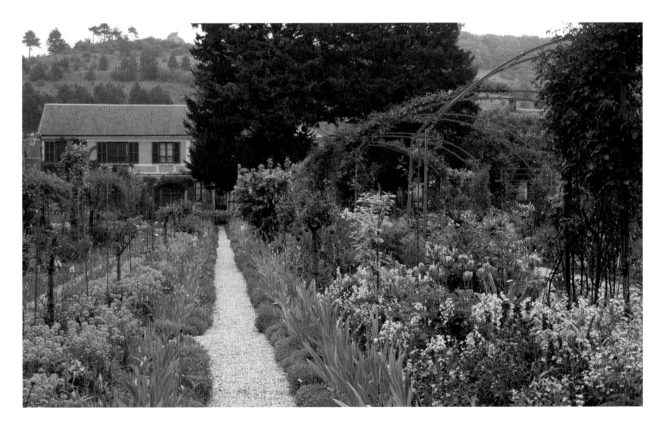

gardeners who believe that improvements in modern plant breeding have been at the expense of flavor that the term has become synonymous with good flavor. The term *heirloom* used to mean any plant variety in existence before World War II, but then this definition was changed to refer to any variety introduced prior to the past 50 years. More recently, because of the demand for heirlooms, some seed companies consider an heirloom to be any non-hybrid variety, irrespective of its year of introduction.

Monet did not care whether his seeds were fifty years old or any other definition of heirloom. Indeed, he poured over seed catalogs diligently searching for novelties to try, even visiting the test gardens of commercial seed growers to evaluate their most recent introductions. Since a variety of a vegetable could vary in quality among seed companies, if Monet found an especially good strain from a particular seed company, he would save the seed for planting in successive seasons and even give packets to his friends as gifts.

Neither did the term *hybrid* deter his choice; in fact, it was quite the opposite. All his water lilies and most of his irises and dahlias were hybrids. Rutabaga, or swede (British), is a hybrid between a turnip and a cabbage and is valued for its ability to store all through winter months, often left out in the garden.

Monet's Farmyard

In addition to a bountiful vegetable garden, Monet maintained a flock of poultry, including chickens, ducks and turkeys, for animal protein. At one time he even kept a goat, which was used to pull a cart. Were it not for the fact that farms close to Giverny provided fresh pork, lamb, milk and beef, he undoubtedly would have raised more livestock. Also, Monet was fortunate to have the seaport of Dieppe close by to supply fresh seafood from the Atlantic Ocean, including flounder, lobster, shrimp, cod, herring, eel, crabs and mussels. Monet's sons and stepsons were avid hunters, and in the countryside around Giverny they found plenty of small game, such as wild rabbit and woodcock. The boys also enjoyed fishing in Monet's pond and occasionally brought home pike, which he preferred among the local freshwater fishes.

The ducks, turkeys and chickens were kept in pens close to the kitchen. The ducks had a small pond and shrubs under which to nest and lay their eggs. There were several kinds, including White Indian Rubbers and Khaki Campbells. Duck was a favorite main dish when hosting guests.

For chickens he raised Faverolles, Houdans, Gatinaise, and Bresse.

Blanche saw to the day-to-day routine of feeding the poultry, while Marguerite's husband, Paul, would collect the eggs each morning and catch and prepare the birds required for the table. He used the eggs in various recipes, such as scrambled eggs with mushrooms from the basement of the Blue House, and omelets with fresh herbs from the kitchen garden. Marguerite even used chopped hard-boiled eggs in her horseradish sauce.

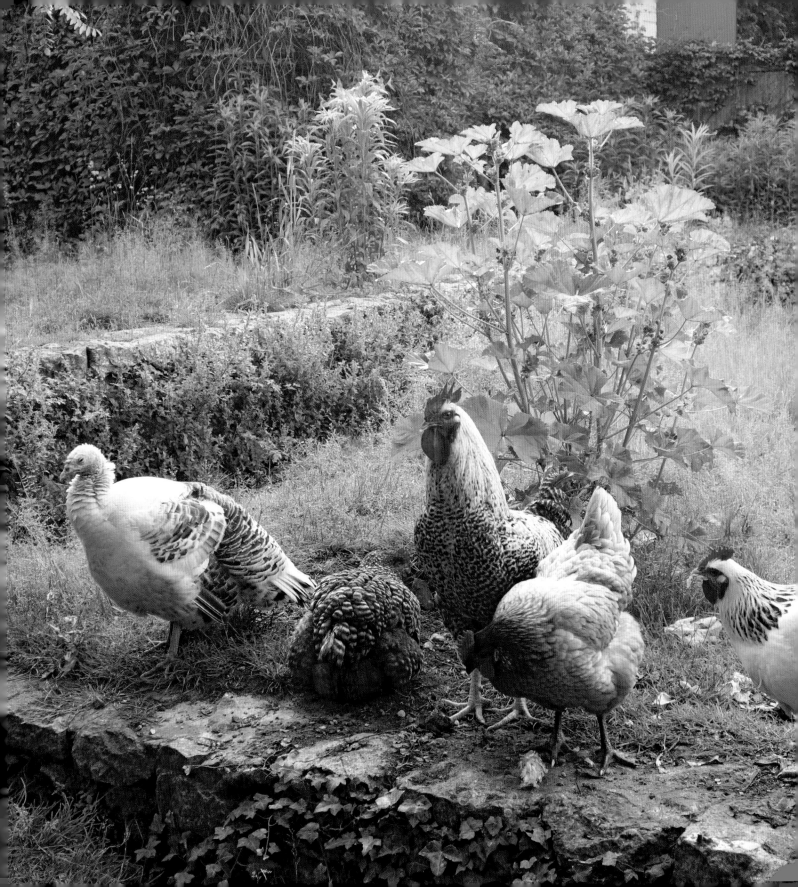

The Recipes

THE FOLLOWING RECIPES ARE LINKED TO MONET'S KITCHEN GARDEN AT GIVERNY, his lifestyle , and zest for entertaining friends and family. Many of them are of French origin, savored by Monet during his travels throughout France. Others are from locations where Monet traveled abroad, including London, Oslo and Venice. For example, at the Savoy Hotel in London he relished Yorkshire pudding, a cup-shaped baked dough that serves as a vessel to hold a thick brown gravy served with roast beef (see page 116).

When guests were invited to lunch, Marguerite would invariably produce a dish that honored the guest. For example, Renoir is known to have liked a particular kind of bouillabaisse (see page 106) and Cezanne provided a cod recipe. Marguerite kept notebooks of recipes, although to follow them precisely would rarely achieve the desired result. She was secretive about her methods, often omitting an important ingredient and occasionally giving an incorrect cooking time. When asked about a particular recipe she was usually vague: "You add a little water, some salt. How much? Not much."

Some of the recipes here are from celebrity chefs who prepared dishes inspired by Monet's cooking journals and featured in the film *Monet's Palate.* In these recipes you have the necessary information to prepare dishes for entertaining guests as Monet would have. If you do not have space for your own kitchen garden or have access to a farmers' market, perhaps these recipes will inspire you to begin a small plot. Even a pot of parsley or chives on a sunny windowsill can link to Monet's palate.

Appetizers

Camembert Fritters with Apple and Raisin Chutney 62

Lentil Soup with Kale and Pearl Onions 65

Melon with Cured Ham, Mint and Sweet Balsamic Drizzle 67

Apple and Fennel Soup with Savory Baguette Croûtes 68

Smoked Salmon, Goat Cheese, Thyme and Chive Spread 70

Roasted Carrot Soup with Ginger, Cumin,
Coriander and Toasted Almonds 73

Spinach, Fennel and Orange Salad with Sunflower
Seeds and Tarragon Dressing 74

Roasted Butternut Squash Soup 76

The Sunday Pot 77

Raw Zucchini Salad with Roquefort, Hazelnut and Herbs 79

Shrimp and Tricolor Pepper Salad with
Creamy Dijon Vinaigrette 80

Watercress, Tomato and Mimolette Cheese Salad 82

Mixed Greens and Roasted Beet Salad with
Pecans and Roquefort Dressing 85

Camembert Fritters with Apple and Raisin Chutney

APPLE AND RAISIN CHUTNEY

1/2 cup (160 g) apple jelly

1/4 cup (50 g) sugar

1 tablespoon curry powder

1 1/2 teaspoons peeled and grated fresh ginger

1/8 teaspoon ground cinnamon

1/8 teaspoon ground cloves

1 1/2 cups (350 ml) water

2 cups (200 g) peeled, cored and diced Granny Smith apples

1/2 cup (75 g) raisins

1/8 teaspoon red pepper flakes

Camembert is the king of cheese in Normandy, and cheese makers that produce some of the best are a short distance from Monet's front door in Giverny. The apple is the queen of fruit in Normandy, and the trees that produce the crisp orb for eating, cooking and baking are abundant. The marriage of Camembert and apples is, therefore, inevitable. Here the two ingredients are joined in holy matrimony in a standout starter that is modern and elegant. Pour a dry alcoholic cider or a buttery chardonnay.

FOR CHUTNEY: Place apple jelly, sugar, curry powder, ginger, cinnamon and cloves in a large heavy saucepan. Add water and stir to blend. Bring to boil. Reduce heat, add apples and simmer 10 minutes. Add raisins and red pepper flakes and simmer 10 minutes, stirring occasionally. Transfer to a bowl and cool to room temperature. *(Can be prepared 1 day ahead. Cover and refrigerate. Bring to room temperature before serving.)*

(continued)

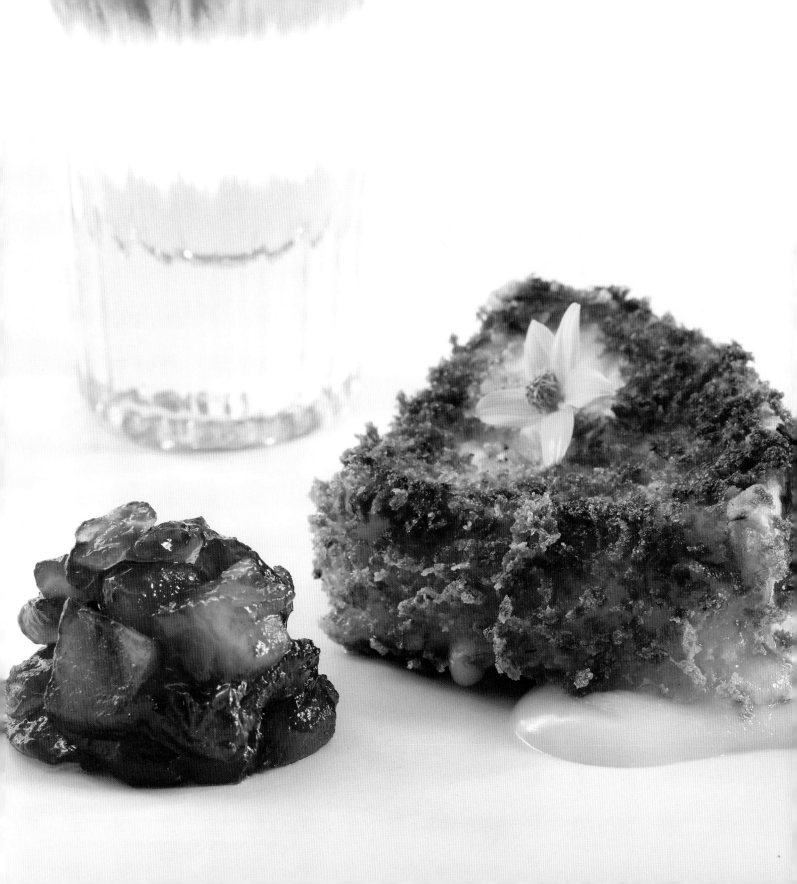

CAMEMBERT FRITTERS

3 ounces (85g) panko
(Japanese breadcrumbs)

2 tablespoons minced fresh flat-leaf parsley, plus more for serving

1/4 teaspoon garlic powder

1/4 teaspoon salt

1/4 teaspoon freshly ground pepper

1/4 cup (30 g) all-purpose flour

2 eggs

1 (1-pound) (450 g) round barely ripe Camembert cheese, cut into 8 wedges

Vegetable Oil

FOR FRITTERS: Combine panko, 2 tablespoons parsley, garlic powder, salt and pepper in shallow bowl or pie plate. Place flour in another shallow bowl or pie plate. Place eggs in another shallow bowl or pie plate. Using fork, beat eggs to blend. Dredge cheese wedge in flour, shaking off excess. Dip in egg, allowing excess to drip back into bowl. Roll in panko. Place on baking sheet. Repeat with remaining cheese wedges

Heat 1/4 inch (1/2 cm) of vegetable oil in the bottom of a large heavy skillet. When bubbles appear, add cheese wedges to skillet (in batches if necessary; do not crowd) and fry until golden brown, about 1 minute per side. Remove from skillet using a slotted spoon and drain on paper towels.

TO SERVE: Place each cheese wedge on a plate. Top with chutney. Sprinkle with remaining parsley.

Lentil Soup with Kale and Pearl Onions

6 APPETIZER SERVINGS

4 cups (1 l) water

1 teaspoon salt

1 bay leaf

1 cup (200 g) dry green lentils, preferably Le Puy, washed, pebbles discarded

2 tablespoons (30 ml) olive oil

1 medium-size onion, diced

1 carrot, peeled and diced

1 celery stalk, diced

2 garlic cloves, minced

8 cups (550 g) chopped kale

1 large baking potato, peeled and diced

1 cup (130 g) fresh or frozen peeled pearl onions

5 cups (1,2 l) low-sodium vegetable broth or stock

1 cup (240 ml) water

1 cup (200 g) chopped seeded tomato

Freshly ground pepper

Monet's cook, Marguerite, most certainly would have had a comforting soup like this bubbling away on the stove in the artist's sky-blue kitchen on a crisp fall day. With any luck there would have been a loaf of country bread baking in the oven. Why not replicate the experience in your own kitchen? This hearty soup is packed with everything that is good for you, including lentils and kale and even pearl onions, which Monet grew in his kitchen garden. He would have adored the addition of just-picked garden-fresh baby onions to this *potage*. Serve it for lunch or supper accompanied by crusty bread and an assortment of cheeses. Pour a rustic red such as Cahors.

Place 4 cups (1 l) water, salt and bay leaf in a large pot. Bring to boil. Add lentils, reduce heat and simmer until tender, about 30 minutes. Drain lentils; discard bay leaf.

Heat oil in a large heavy pot over medium heat. Add onion, carrot, celery and garlic and sauté until onion is translucent, about 10 minutes. Stir in lentils, kale, potato and pearl onions. Add broth, water and tomato and bring to boil. Reduce heat and simmer until potato is fork tender, about 30 minutes. Adjust seasoning with salt and pepper. Ladle soup into bowls and serve immediately.

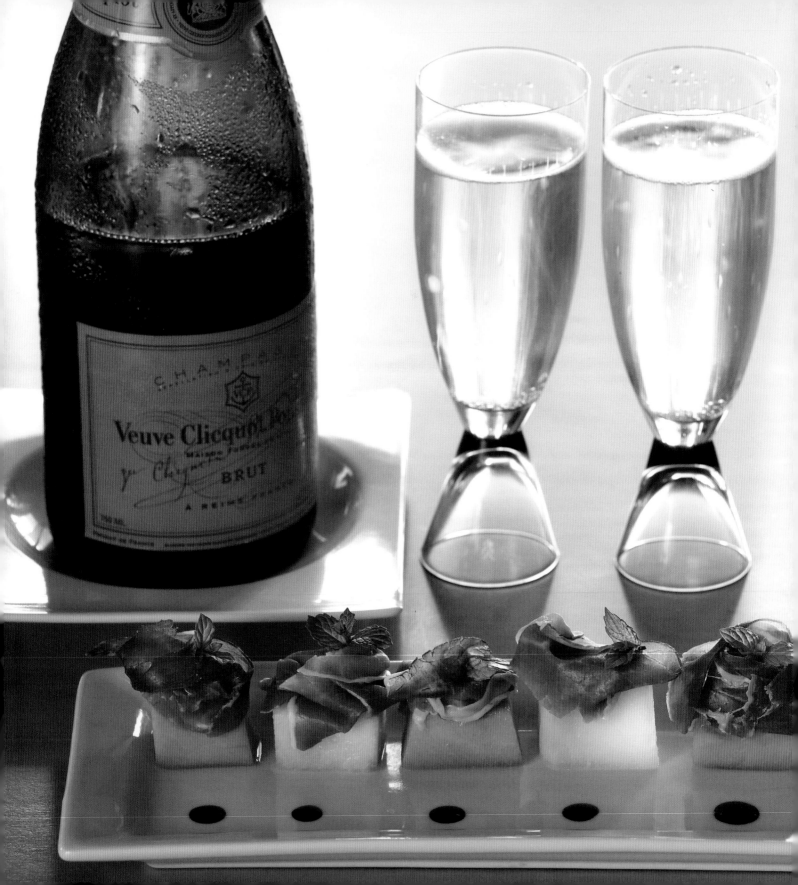

Melon with Cured Ham, Mint and Sweet Balsamic Drizzle

4 APPETIZER SERVINGS

¼ cup (60 ml) balsamic vinegar

1 tablespoon (20 g) honey

1 ripe Charentais melon or cantaloupe, peeled, seeded and cut into eight slices

8 very thin slices of jambon de Bayonne or prosciutto ham

1 tablespoon chopped fresh mint

Salt

One of Monet's most admired paintings is *Still Life with Melon*. Needless to say, Monet adored melon and grew the luscious fruit in his kitchen garden. The famous French Charentais melon, which is small and ribbed, with the most divine, fragrant, sugary and juicy flesh, is worth searching out at farmers' markets or even growing in your own garden; cantaloupe makes a good substitute. The melon pairs beautifully with the sweet yet salty cured French ham known as jambon de Bayonne, which is available at gourmet food stores and supermarkets; prosciutto is equally delicious. The crowning touch is the rich balsamic reduction, which brings all the flavors together; do not use expensive balsamic here, as that is already thick and sweet; a regular one will do. And the mint adds brightness. Why not pour Champagne for a festive touch? Monet would always pour his favorite Veuve Clicquot at Christmas and special occasions.

Place vinegar and honey in a small heavy saucepan over medium heat and bring to boil, whisking occasionally. Reduce heat and simmer, whisking occasionally, until mixture reduces by half and coats the back of a wooden spoon. Remove from heat and cool completely.

Wrap each slice of melon in a piece of ham. Arrange slices on a platter. Drizzle with vinegar reduction. Sprinkle with mint and salt.

Apple and Fennel Soup with Savory Baguette Croûtes

CROÛTES

8 (1/2-inch) (1,5 cm) slices of slightly stale baguette

2 tablespoons butter, (30 g) melted

1 tablespoon (15 ml) olive oil

1 tablespoon minced fresh parsley

1/2 teaspoon garlic powder

1/2 teaspoon dried thyme, crumbled

1/8 teaspoon freshly ground pepper

Renoir's wife, Aline, was a gourmet cook, and fennel soup was one of her specialties. Monet loved her fennel soup so much that whenever he dined at the Renoir household it was sure to be on the menu. There is no doubt that Monet's cook, Marguerite, made her own version of the soup with fennel picked fresh from the kitchen garden. We are sure Monet would love our rendition. Its complementary combination of fennel, with its slight licorice flavor, and apple, with its sweet tang, augmented with parsnip, celery and potato is sure to please. This soup is perfect before a dinner of sautéed pork chops or roast pork with wild rice, or makes for a hearty lunch or supper accompanied by a salad and cheese. A sparkling cider would work beautifully as a beverage. Please note that, as this soup is made with vegetable stock, it is vegetarian.

FOR CROÛTES: Preheat oven to 375 F (190 C). Arrange baguette slices in single layer on nonstick baking sheet. Combine melted butter and olive oil in a small bowl. Brush bread evenly with mixture. Sprinkle evenly with parsley, garlic powder, thyme and pepper. Bake until crisp and slightly browned, about 5 minutes. Set aside until ready to use.

SOUP

1 tablespoon (15 ml) olive oil

1 medium-size onion, diced

1 medium-size parsnip,
peeled and diced

1 celery stalk, diced

2 garlic cloves, coarsely chopped

Salt

3 medium-size Granny Smith
apples, peeled, cored and diced

1 large boiling potato,
peeled and diced

1 medium-size fennel bulb,
trimmed and diced, fronds
reserved and chopped

1 1/2 quarts (1,5 l) low-sodium
vegetable stock or broth

1/2 quart (0,5 l) water

1/2 cup (120 ml) whipping cream

1/4 cup (1/2 stick) (60 g)
butter, room temperature

FOR SOUP: Heat olive oil in a large heavy pot over medium heat. Add onion, parsnip, celery, garlic and a pinch of salt and sauté until onion is translucent, about 10 minutes. Stir in apples, potato and fennel. Pour in stock and water and bring to boil. Reduce heat, cover and simmer 1 hour. Using an immersion blender, puree soup until smooth but still retaining a little texture. Add cream and butter and stir until butter melts.

TO SERVE: Ladle soup into bowls. Top each with 1 croûte. Sprinkle with reserved chopped fennel fronds. Serve immediately.

Smoked Salmon, Goat Cheese, Thyme and Chive Spread

1 1/2 cups (300 g) fresh goat cheese, room temperature

3 tablespoons (45 ml) half-and-half

2 tablespoons snipped fresh chives

1 tablespoon chopped fresh thyme

1 teaspoon finely chopped lemon peel

1/4 teaspoon salt

1 teaspoon freshly ground pepper

1/4 pound (110 g) Norwegian smoked salmon slices, roughly chopped

1 baguette, thinly sliced

Monet's stepson Jacques lived in Oslo, Norway, and Monet visited him there. They made a side trip to Sandvika, where Monet painted an iron bridge that was reminiscent of the Japanese bridge at his home in Giverny. The cool Norwegian climate and crisp Norwegian apple cider made him think of Normandy. And the salmon was divine! Here we take that salmon and combine it with goat cheese as well as fresh thyme and chives, two herbs that grew along the borders of rosemary bushes in Monet's kitchen garden. Pair this quick and easy starter with a dry apple cider or a light sparkling wine such as cava or Prosecco.

Place goat cheese, half-and-half, chives, thyme, lemon peel, salt and pepper in a medium-size bowl. Using a wooden spoon, mix well. Add salmon and fold in. *(Can be prepared 1 day ahead. Cover and refrigerate. Bring to room temperature before serving.)* Transfer to a serving bowl. Place on a platter. Surround with baguette slices.

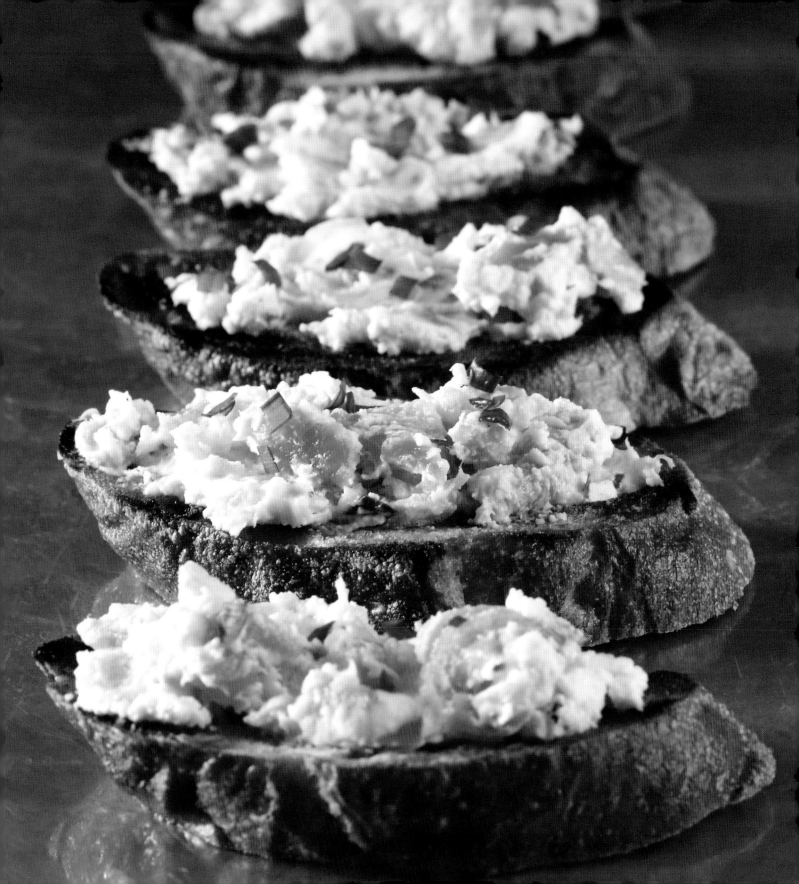

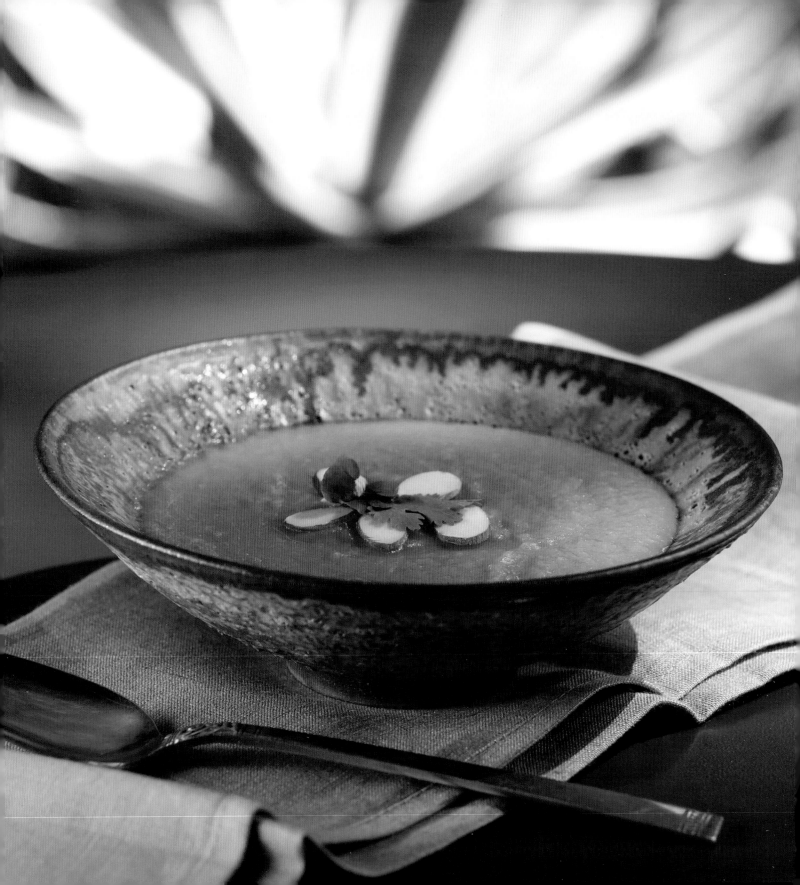

Roasted Carrot Soup with Ginger, Cumin, Coriander and Toasted Almonds

2 pounds (900 g) carrots, peeled and cut into 1/2-inch (1,5 cm) pieces

1 celery stalk, diced

1 onion, diced

1 large baking potato, peeled and diced

5 whole garlic cloves, peeled

1 tablespoon peeled and chopped fresh ginger

1 teaspoon ground cumin

2 tablespoons (30 ml) extra virgin olive oil

3 cups (720 ml) low-sodium vegetable broth or stock

1 cup (240 ml) water

2 tablespoons chopped fresh coriander or cilantro, divided

1 tablespoon (20 g) honey

1 teaspoon salt

1/2 teaspoon freshly ground pepper

1/2 cup (25 g) shredded peeled carrots

1/4 cup (30 g) toasted slivered almonds

Carrots were a staple of Monet's kitchen garden and Monet's cook, Marguerite, used them in a variety of delicious dishes, including simple soups that would have been offered to begin a classic French meal. This soup, while still easy to make, is a bit more exotic in taste than a traditional French recipe. Roasting the carrots brings out their inherent sweetness; the addition of garlic, ginger and cumin adds an earthy depth of flavor; and fresh-from-the-garden coriander, also known as cilantro, adds brightness. Try serving this soup before grilled fish or shellfish; couscous with chicken, lamb or vegetables; or an Indian dish. It is also delicious on its own and makes a perfect vegan lunch or light supper accompanied by crusty oven-baked bread. Pour any chilled white wine.

Place carrots, celery, onion, potato, garlic, ginger and cumin in a roasting pan or on a large rimmed baking sheet. Add olive oil and toss well. Roast until vegetables are tender and lightly caramelized, 35 to 45 minutes.

Transfer vegetables to a large pot. Stir in broth, water, 1 tablespoon coriander, honey, salt and pepper and bring to boil. Remove from heat and cool slightly. Using an immersion blender, puree soup until smooth. Adjust seasoning with additional salt and pepper. Return soup to heat. Add shredded carrots and stir thoroughly. Ladle soup into bowls. Garnish each bowl with a bit of remaining coriander and toasted almonds. Serve immediately.

Spinach, Fennel and Orange Salad with Sunflower Seeds and Tarragon Dressing

2 tablespoons tarragon
leaves, chopped

4 teaspoons (20 ml) orange juice

2 teaspoons Dijon mustard

1/4 teaspoon salt

1/4 teaspoon freshly ground pepper

1/3 cup (80 ml) extra virgin olive oil

6 cups (180 g) baby spinach leaves

3 navel oranges, peeled
and sectioned, divided

1/2 cup (50 g) thinly sliced fennel

1/4 cup (25 g) thinly sliced red onion

2 tablespoon roasted
salted sunflower seeds

The traditional Italian pairing of orange and fennel—here teamed with spinach—gets a particularly Norman accent with the addition of tarragon, an herb that is a staple in every French kitchen garden, including that of Monet. (Note that true French tarragon is not grown from seed, only from cuttings, so look for potted rooted cuttings at your local farmers' market or garden store.) This crunchy and refreshing salad is a delicious prelude to just about anything that is simply roasted or grilled. It also makes a tasty light lunch dish. Pour any chilled dry white wine that you like.

Place tarragon, orange juice, mustard, salt and pepper in a small bowl. Slowly whisk in oil. Pour dressing in a large salad bowl. Add spinach, half of the orange sections, the fennel and onion and toss well. Adjust seasoning with additional salt and pepper if necessary. Garnish with remaining orange sections and sunflower seeds. Serve immediately.

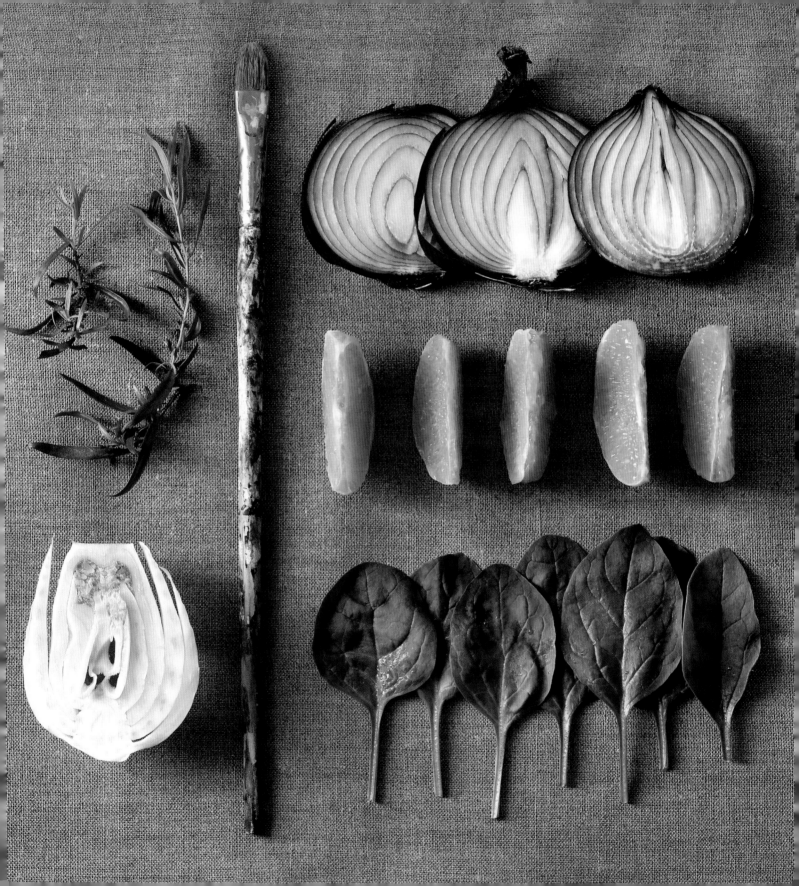

Roasted Butternut Squash Soup

6 APPETIZER SERVINGS

2 pounds (900 g) butternut squash, preferably Waltham, peeled, seeded and coarsely diced

3 tablespoons (45 ml) olive oil, divided

½ cup (75 g) diced onion

½ cup (50 g) diced celery

½ cup (75 g) diced carrot

1 garlic clove, sliced

½ teaspoon salt

¼ teaspoon freshly ground pepper

4 cups (1 l) low-sodium vegetable broth or stock

1 large fresh rosemary sprig

2 tablespoons minced fresh flat-leaf parsley

Monet was fond of winter squash and grew many different kinds in his garden, including butternut, the star of this sublime *potage*. The recipe—inspired by one of Marguerite's cookery journal entries—also works well with other varieties, including acorn, Boston marrow, hubbard and kabocha. All of these squashes have hard shells and sweet yellow or orange flesh, which resembles that of a sweet potato when cooked. We suggest garnishing with crumbled walnuts, that favorite French nut. If you can find store-bought spiced walnuts, even better! This is a beautiful opener for a fall or winter meal, or makes for a luscious lunch accompanied by salad, bread and cheese, or a slice of quiche. Pour a Riesling or Gewurztraminer for a real treat.

FOR SOUP: Preheat oven to 400 F (200 C). Spread squash evenly on a large nonstick baking sheet. Drizzle with 1 tablespoon (15 ml) olive oil and toss well. Roast until fork tender and edges are caramelized, 20 to 30 minutes. Meanwhile heat remaining 2 tablespoons (30 ml) olive oil in a large heavy pot over medium heat. Add onion, celery, carrot, garlic, salt and pepper and sauté until onion is translucent, about 10 minutes. Add roasted squash, broth and rosemary and bring to boil. Remove rosemary. Using an immersion blender, puree soup until smooth.

TO SERVE: Reheat soup if necessary and reduce if too thin. Ladle soup into bowls. Garnish with parsley.

The Sunday Pot

10 APPETIZER SERVINGS

2 quarts (2 l) chicken stock or broth, preferably homemade

1 cup (150 g) chopped onion

1 cup (150 g) peeled and diced carrots

1 cup (150 g) peeled and diced red beets

1 cup (100 g) thinly sliced leek

1 cup (100 g) thinly sliced fennel

1 cup (175 g) chopped zucchini

1 cup (225 g) peeled and diced potato

1 cup (175 g) fresh or frozen yellow corn kernels

1 cup (150 g) shucked fresh or frozen lima beans or shucked fresh or frozen peas

1 cup (25 g) chopped fresh parsley

1 large red heirloom tomato, peeled and cut into bite-size pieces

1 large yellow heirloom tomato, peeled and cut into bite-size pieces

1 large black heirloom tomato, peeled and cut into bite-size pieces

1 tablespoon chopped rosemary

1 tablespoon chopped sage

2 bay leaves

1 large garlic clove, thinly sliced

Salt and freshly ground pepper

Every Sunday Monet chose the vegetables that would constitute what we have named "The Sunday Pot," a fresh vegetable soup. Florimond, Monet's trusted gardener and tender of his kitchen garden, would pick a variety of vegetables and present them to Monet. The classic French variation called *pot au feu* was created by adding beef and was a convenient way to feed the entire Monet family. Florimond knew that the vegetables had to be harvested at just the right time of ripeness or Monet would not be pleased. If Monet was happy with Florimond's selection, it would go into the soup. Obviously the vegetables changed with the seasons, and so should yours. This soup is very forgiving and flexible. You can add, subtract or substitute vegetables and herbs at will, and the soup will still be delicious. If you cannot find the different colors of heirloom tomatoes, not to worry: just use three large red tomatoes. During the colder months, serve this soup piping hot; during warmer months serve it at room temperature. Either way, make sure to drizzle it with some olive oil and sprinkle it with freshly grated Parmesan cheese. Accompany with crusty bread and a sharp cheese. Pour a hearty red wine such as Côtes du Rhône. To make a vegetarian version, use vegetable stock instead of chicken stock.

Place all ingredients except for salt and pepper in a large stock or soup pot. Bring to boil. Reduce heat and simmer 1 hour. Season with salt and pepper. Discard bay leaves and ladle into bowls and serve immediately.

Raw Zucchini Salad with Roquefort, Hazelnut and Herbs

6 APPETIZER SERVINGS

1 tablespoon Dijon mustard

1 tablespoon minced shallot

2 teaspoons (14 g) honey

1/4 teaspoon salt

1/4 teaspoon freshly ground pepper

1/4 cup (60 ml) apple cider vinegar

3/4 cup (180 ml) extra virgin olive oil

3 small green zucchini, halved lengthwise and thinly sliced into half-moon shapes

3 small yellow zucchini, halved lengthwise and thinly sliced into half-moon shapes

2 tablespoons chopped fresh parsley

1/2 cup (70 g) crumbled Roquefort or blue cheese

1/4 cup (30 g) hazelnuts, toasted, skinned and chopped

1 tablespoon snipped fresh chives

The Normans have Monet to thank for introducing zucchini to their region. Always on the alert for new flower and vegetable varieties to grow from seed during his travels, he discovered the round, green and striped Ronde de Nice variety (meaning "Round from Nice") at a farmers' market in Provence, near the Italian border. In this refreshing salad we call for raw zucchini, so make sure to pick young small fruits that are no more than 5 inches (15 cm) long for perfect tenderness. Here they are cut into cubes and wedges, dressed simply and adorned with fragrant blue cheese, nuts and herbs. Serve this salad before grilled chicken, fish or lamb or on its own for a light lunch or supper accompanied by slices of crusty baguette. Pour a chilled fruity white or light red wine, or even a semi-dry cider.

Whisk together mustard, shallot, honey, salt and pepper in the bottom of a large bowl. Whisk in vinegar. Slowly drizzle in oil, whisking constantly. Add sliced zucchini and parsley to bowl and toss well with vinaigrette. Transfer zucchini to a large platter. Sprinkle evenly with cheese, nuts and chives. Serve immediately.

Shrimp and Tricolor Pepper Salad with Creamy Dijon Vinaigrette

1/3 cup (80 ml) red wine vinegar

3 tablespoons Dijon mustard

1 garlic clove, crushed

1/4 teaspoon freshly ground pepper

1/8 teaspoon salt

3/4 cup (180 ml) extra virgin olive oil

1 pound (450 g) cooked, peeled and deveined shrimp (21 to 25 shrimp)

1/4 cup (40 g) diced red bell pepper

1/4 cup (40 g) diced green bell pepper

1/4 cup (40 g) diced yellow bell pepper

2 tablespoons (20 g) diced red onion

1 tablespoon capers, rinsed and drained

6 cups (450 g) chopped romaine lettuce

3 tablespoons chopped fresh flat-leaf parsley

Monet grew bell peppers in the same plot with his tomatoes since they are closely related and require the same growing conditions, and he often combined them in his cooking. Most sweet bell peppers start off as green before they turn into other colors. We call for red, green and yellow peppers here for a carnival of color, but you could also add slices of orange, purple, black or cream. This is a light and luscious luncheon dish on its own. Follow with some hearty bread, cheese and grapes, or a fruit tart. Pour any chilled white wine that you like.

Whisk vinegar, mustard, garlic, pepper and salt together in a large salad bowl. Gradually drizzle in oil, whisking until smooth. Add shrimp, all bell peppers, onion and capers and stir well to coat. Refrigerate 20 minutes.

Divide lettuce among 6 salad plates. Divide shrimp salad among plates. Sprinkle with parsley. Serve immediately.

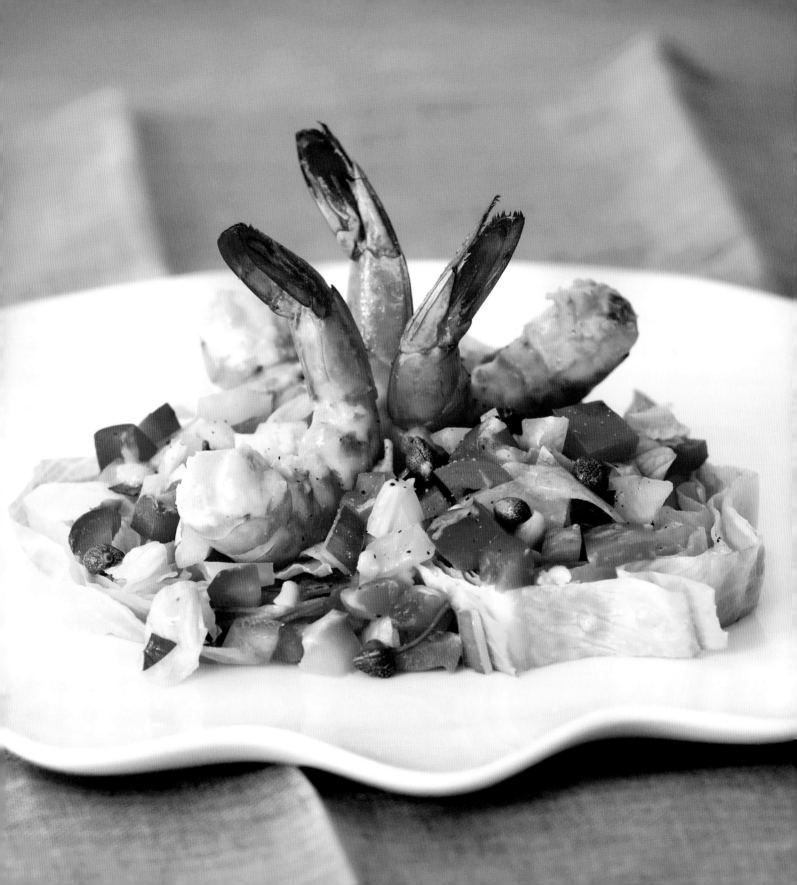

Watercress, Tomato and Mimolette Cheese Salad

6 APPETIZER SERVINGS

1 tablespoon Dijon mustard

1 1/2 teaspoons minced shallot

1/4 teaspoon salt

1 tablespoon fresh lemon juice

1/4 cup (60 ml) extra virgin olive oil

2 bunches watercress,
stems removed

1 cup (150 g) halved
cherry tomatoes

1 teaspoon freshly ground pepper

1/4 cup (30 g) Mimolette or
Parmesan cheese shavings

The watercress farms of Saint-Marcel, located close to Giverny, supplied the Monet family with an abundance of the fragrant and nutritious salad green. So important to the area was watercress that the town of Vernon, the main town near Monet's home, uses an image of watercress as part of its coat of arms. Here the peppery plant is tossed with cherry tomatoes and the classic vinaigrette that Monet enjoyed. It's topped with the traditional French cheese Mimolette, with its bright orange color and distinct nutty flavor. If you can't find Mimolette, use Parmesan instead. This salad is perfect before a simple meal of *steak-frites*, roast chicken with roasted potatoes, or grilled fish with mashed potatoes. Pair with a crisp French Chablis.

Place mustard, shallot and salt in a large salad bowl, preferably wooden. Whisk in lemon juice. Gradually whisk in olive oil; dressing should emulsify. Add watercress, tomatoes and pepper and toss well. Garnish with cheese. Divide among salad plates and serve.

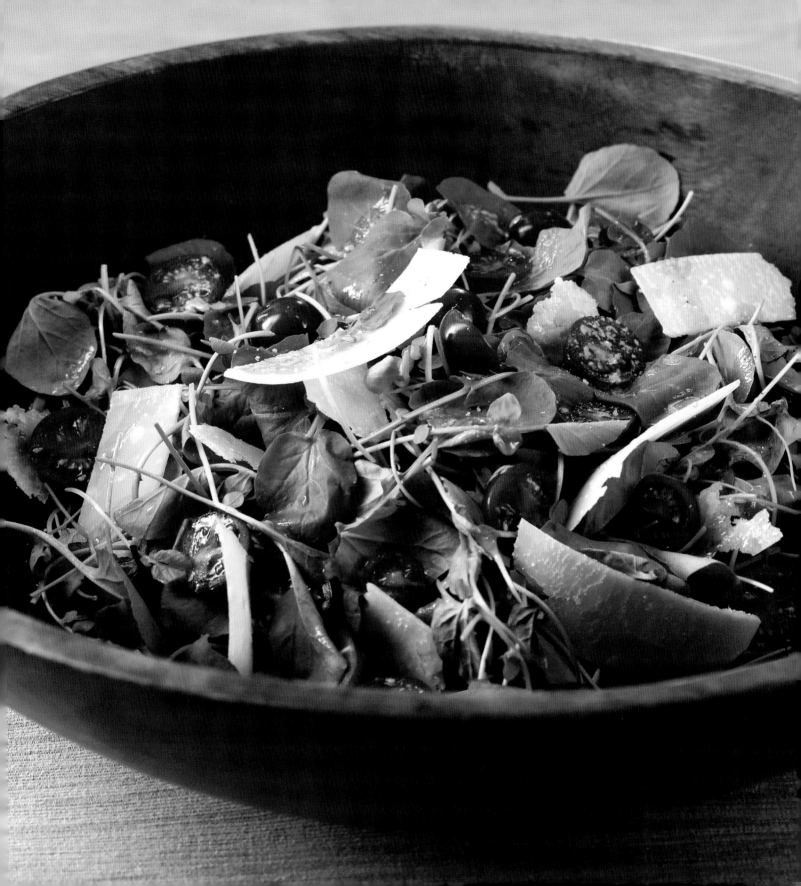

THE HOTEL BAUDY, GIVERNY

Located in the center of Giverny village, this charming hotel was established by Angelina and Lucien Baudy beside the main street, rue Claude Monet, just a short walk from Monet's house and garden. After Monet established himself in Giverny, he was visited by many American painters, including Metcalf, Sargent and Butler (who married Monet's stepdaughter Suzanne). Among French painters who patronized the Hotel Baudy were Cezanne, Pissarro and Renoir.

Although the hotel does not provide accommodations today, it has a fine restaurant serving good food; the walls are decorated with archive photographs of famous patrons. Meals can also be enjoyed outside in the rose garden or on a shaded terrace. The rose garden is especially beautiful since it includes many heirloom varieties of shrubs and climbing roses.

Mixed Greens and Roasted Beet Salad with Pecans and Roquefort Dressing

6 APPETIZER SERVINGS

½ cup (70 g) crumbled Roquefort, Gorgonzola or other blue cheese

¼ cup (60 ml) balsamic vinegar

1 tablespoon minced garlic

¼ teaspoon salt

¼ teaspoon pepper

¾ cup (180 ml) extra virgin olive oil

1½ pounds (700 g) mixed salad greens (any combination of romaine, arugula, radicchio, butter lettuce, mizuna, escarole, curly endive, red leaf or other lettuce)

6 large beets, roasted, peeled and quartered

½ cup (60 g) chopped pecans

The French adore green salads (*salades vertes*) and Monet was no exception. He and his family always had two bowls full of fresh-from-the-garden greens—Monet grew lots of romaine in his lettuce bed—simply dressed with olive oil and red wine vinegar, plus copious amounts of sea salt and freshly ground pepper. This kind of salad is usually served after the main course and before dessert, sometimes alongside or followed by a cheese course. Monet enjoyed blue-veined cheeses—especially French Roquefort (made from sheep's milk) and Italian Gorgonzola (made from cow's milk). Here we combine the greens and the cheese with roasted beets and nuts in a salad that has become something of a modern French classic. While the French may use walnuts or pine nuts, we prefer pecans for their rich flavor. This particular salad is often served before the meal, and is especially tasty preceding something such as *steak-frites* or *poulet-frites*.

Combine cheese, vinegar, garlic, salt and pepper in a small bowl. Whisk in olive oil in a steady stream to make dressing. Toss greens and beets in a large salad bowl; pour dressing over. Toss well. Sprinkle with pecans. Serve immediately.

Main Courses

Aromatic Mussels with White Wine,
Crème Fraîche and Tomatoes 89

Sautéed Salmon with Herb,
Garlic and Citrus Butter and
Sautéed Baby Vegetables 93

Boeuf Bourguignon with Rosemary
Puff Pastry Crust 95

Roasted Cod with Fresh Corn, Red
Pepper, Onion and Caper Salad 98

Grilled Lamb Chops with Parsley
and Mint Vinaigrette 100

Crispy Duck Breasts with Berry and
Orange Glaze,
Mashed Potatoes and Peas
and Carrots 103

Roast Pork with Cherry Sauce 105

Bouillabaisse with Aïoli 106

Gratin of Turbot, Carrots and Leeks
with Cider and Cream 108

Camembert Scrambled Eggs
with Tomato and Chives Topped
with Asparagus and Morel
Mushroom Sauté 109

Cold Poached Salmon with Endive,
Tomato and Red Onion Salad 113

Baked Cheese-Stuffed
Portobello Mushrooms with
Herbed Tomato Sauce 114

Roast Beef and Yorkshire Pudding
with Gruyère and Herbs 116

Omelet with Goat Cheese
and Fresh Herbs 119

Moussaka for Monet 120

Pasta with Broccoli, Brown
Butter and Sage 122

Venetian-Style Spaghetti
with Roasted Tomatoes,
Anchovies and Capers 125

Aromatic Mussels with White Wine, Crème Fraîche and Tomatoes

6 APPETIZER OR 4 MAIN COURSE SERVINGS

4 to 6 pounds (1,8 kg to 2,7 kg) fresh mussels

½ bottle (375 ml) dry white wine

3 shallots, minced

1 garlic clove, minced

1 bouquet garni (2 bay leaves, 2 thyme sprigs, 2 parsley sprigs tied together)

Freshly ground pepper

1 cup (240 g) crème fraîche

¼ cup (50 g) chopped tomatoes

Salt

2 tablespoons chopped fresh parsley

The rugged coastline between Dieppe and Honfleur is famous for the quality of shiny black-shelled mussels (*moules*), which many locals pluck from the rocks at low tide and steam in a bucket right on the beach. We can visualize Monet doing exactly the same during his painting trips, since he often had Marguerite cook a local dish known as *moules marinières*. Anne Willan, esteemed British chef, author, and founder of the famed La Varenne Cooking School in France, created this easy yet elegant mussels recipe that bursts with the flavors of Monet's Normandy. The mussels, crème fraîche and herbs from Monet's kitchen garden would come together in just minutes. Serve with lots of crusty bread to sop up the cooking juices, and pour cider, Sancerre or Chablis.

Place mussels in a colander and rinse under cold running water. Remove beards from mussels if necessary. Discard any open mussels that do not close when tapped. Pour wine into a large heavy pot. Stir in shallots, garlic and bouquet garni. Season well with pepper. Bring to boil over high heat and cook 2 minutes. Add mussels, cover and cook until mussels open, 5 to 7 minutes. Discard any mussels that do not open. Using a large slotted spoon, transfer mussels to shallow bowls. Stir crème fraîche and tomatoes into cooking liquid. Season with salt if necessary. Stir in parsley. Spoon liquid over mussels in bowls. Serve immediately.

MONET'S PASSION FOR SEAFOOD

Monet had a special liking for seafood. He loved to paint the coastline between Dieppe and Varengeville-sur-mer. At La Terrasse hotel and restaurant, located a short walk from the cliff-top where Monet completed 22 canvases, *fruits de la mer* is a specialty. A *fruits de la mer* seafood platter is so highly prized throughout France it is a tradition to serve it on Christmas Eve after opening Christmas gifts. The entire assemblage is served over crushed ice using a platter with several tiers and displaying the ingredients artistically among seaweed and sprigs of parsley for decoration.

Popular ingredients include steamed lobster tail, prawns, crab, small cold-water shrimp, mussels, clams and raw oysters served with a shallot vinaigrette.

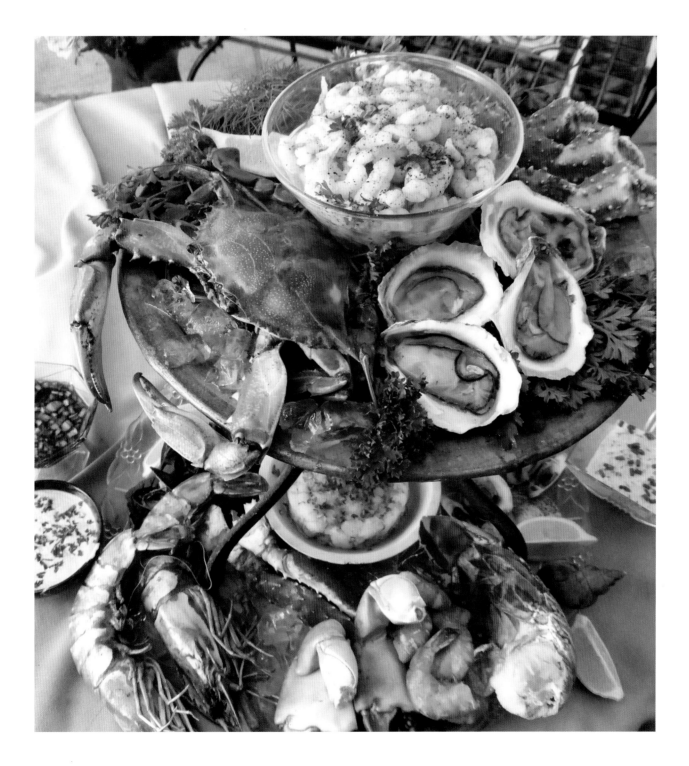

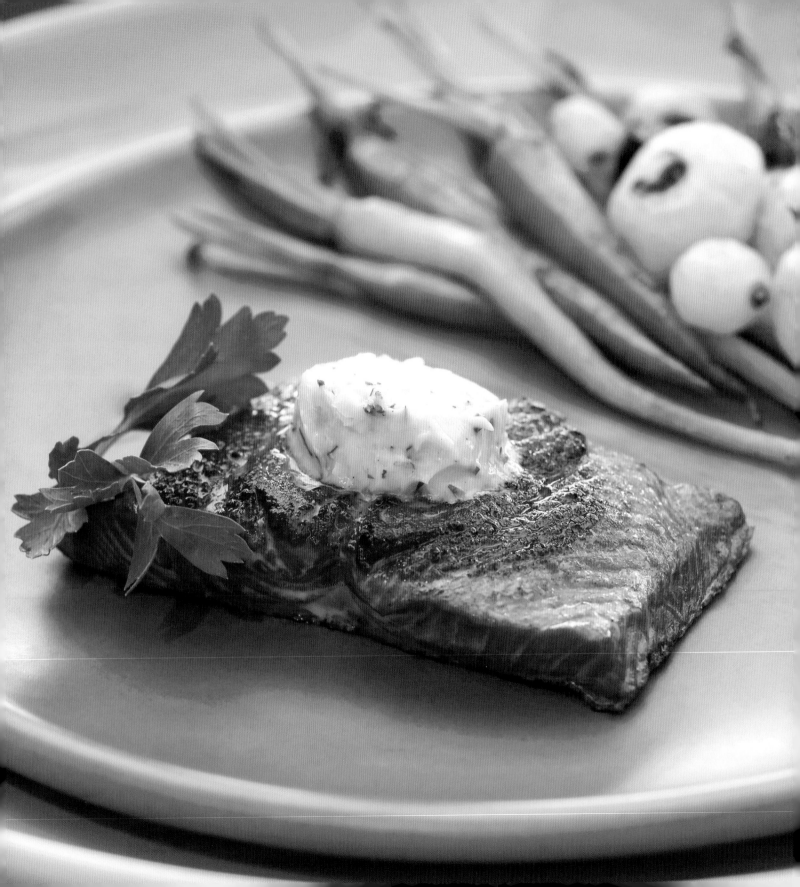

Sautéed Salmon with Herb, Garlic and Citrus Butter and Sautéed Baby Vegetables

BUTTER

1 tablespoon (15 ml)
extra virgin olive oil

1 tablespoon minced garlic

1 teaspoon sea salt

1/2 cup (1 stick) (115 g) unsalted
butter, room temperature

1 tablespoon (15 ml)
fresh orange juice

1 teaspoon grated orange peel

2 tablespoons minced
fresh flat-leaf parsley

2 tablespoons minced dill

2 tablespoons finely snipped chives

1 tablespoon minced thyme

1 teaspoon freshly ground pepper

Monet traveled to Norway to visit his son, where he enjoyed painting snow scenes and feasting on wild Atlantic salmon. He also traveled to England, where he was no doubt served Scottish salmon from the rivers Spey and Findhorn. But he didn't have to leave home to find arguably the best butter in the world: Normandy butter is revered for its sweet, creamy flavor and deep yellow color. Here we top the salmon—simply sautéed—with a compound butter filled with fresh herbs from the kitchen garden. We accompany the fish with sautéed baby vegetables that Monet grew. Serve with a chilled white wine such as Sancerre or Chardonnay.

FOR BUTTER: Heat oil in a small heavy skillet over low heat. Add garlic and salt and sauté 3 minutes. Cool completely. Place room-temperature butter in a medium-size bowl. Stir in orange juice and peel, then stir in parsley, dill, chives, thyme, pepper and cooled garlic. Line a small baking sheet with waxed or parchment paper. Shape butter into cylinder or log and set in center of one short end of paper. Roll up paper as for a jelly roll until butter is entirely enclosed in paper. Using kitchen string or twine, tie paper on both ends. Refrigerate at least 8 hours or overnight. *(Can be prepared 1 week ahead and refrigerated or frozen. If frozen, defrost before using.)*

(continued)

VEGETABLES

8 tablespoons (1 stick) (115 g) unsalted butter, divided

2 cups (300 g) small farmers' market carrots, peeled and trimmed

1 cup (150 g) baby turnips, peeled and halved

8 baby red beets, peeled and quartered

1/4 cup (60 ml) water

1 cup (130 g) fresh or frozen and defrosted pearl onions, peeled

2 tablespoons finely snipped chives

2 tablespoons chopped fresh flat-leaf parsley

Salt and freshly ground pepper

SALMON

6 (6- to 8-ounce) (170 g to 225 g) skin-on salmon fillets, preferably wild caught, pin bones removed

Extra virgin olive oil

1/2 teaspoon salt

1/2 teaspoon freshly ground pepper

1/4 teaspoon minced dried rosemary

FOR VEGETABLES: Melt 2 tablespoons butter in a large heavy skillet over medium heat. Add carrots, turnips and beets and sauté 5 minutes. Add water and onions and stir well. Increase heat and bring to boil. Reduce heat, cover and simmer until vegetables are fork tender; time will vary depending on size of vegetables. Swirl in remaining 6 tablespoons butter, chives and parsley. Season with salt and pepper. Cover and keep warm until ready to serve.

FOR SALMON: Preheat a large nonstick skillet over medium-high heat. Meanwhile, arrange salmon fillets skin side up on a baking sheet. Brush with olive oil. Sprinkle with salt, pepper and rosemary. Place salmon skin side down in skillet (cook in batches if necessary; do not crowd skillet) and cook until skin is crisp and browned, 3 to 4 minutes. Using spatula, turn salmon over and cook until salmon is medium rare, about 4 minutes; cook longer if salmon is thick or if you prefer cooked through. Turn off heat but leave salmon in skillet; salmon will continue cooking from residual heat.

TO SERVE: Remove butter from paper. Cut butter into medallions. Set 1 salmon fillet on each plate. Top each salmon fillet with butter medallion. Divide vegetables among plates. Serve immediately.

Boeuf Bourguignon with Rosemary Puff Pastry Crust

6 MAIN COURSE SERVINGS

3 pounds (1, 350 kg) beef chuck, cut into 1-inch cubes

6 ounces (170 g) white button mushrooms, quartered

1 cup (150 g) diced onion

1 cup (150 g) diced peeled carrot

1 cup (100 g) diced celery

1/2 cup (75 g) diced peeled turnip

4 garlic cloves, minced

1 bottle (750 ml) good dry red wine such as pinot noir or zinfandel

1 bouquet garni (2 sprigs fresh flat-leaf parsley, 1 sprig fresh thyme, 1 sprig fresh rosemary and 1 bay leaf tied together)

1 teaspoon salt, plus more for seasoning beef

1/2 teaspoon freshly ground pepper, plus more for seasoning beef

4 tablespoons (60 ml) canola or other vegetable oil, divided

8 ounces (225 g) unsliced smoked bacon, diced

4 tablespoons (1/2 stick) (60 g) unsalted butter, room temperature, divided

This classic beef stew hails from Burgundy but is beloved throughout France. It makes use of a number of vegetables and herbs that Monet grew in his garden. In a modern twist, we top it with puff pastry—dough made with layers of butter—which is extremely popular in Normandy, where butter is king. This really is a one-pot meal, but to up the Normandy quotient you could follow with a salad and one or more cheeses from the region: Camembert and Pont-l'Evêque are just two luscious examples. Or you could round things out with baked apples or an apple tart (see our recipes on page 151 and page 147). Pour the same wine you use for the meat marinade: a pinot noir or a zinfandel. P.S. Since the meat needs to marinate overnight for this recipe, you need to start preparation one day before you plan to serve it. Also, if you want to make a vegetarian version, use Portobello mushrooms instead of beef, vegetable stock instead of beef broth, and forget the bacon.

Combine beef, mushrooms, onion, carrot, celery, turnip and garlic in large non-aluminum bowl. Pour wine over and stir well. Add bouquet garni. Cover and refrigerate mixture overnight.

Drain beef mixture, reserving liquid. Pour liquid into a medium-size heavy non-aluminum saucepan and bring to boil. Continue boiling until reduced by half. Set aside until ready to use.

(continued)

¼ cup (60 ml) sweet Port

2 cups (0,5 l) beef broth or stock

1 tablespoon (15 g) tomato paste

2 tablespoons (15 g) all-purpose flour, plus more for rolling out dough

1 sheet frozen puff pastry, thawed but still cold

1 teaspoon dried rosemary, crumbled

Meanwhile, separate beef and vegetables and place in separate bowls. Discard bouquet garni. Season beef with salt and pepper. Heat 2 tablespoons (30 ml) oil in a large Dutch oven or other large heavy pot over medium-high heat. Add half of the beef and brown well on all sides. Transfer to platter. Add remaining 2 tablespoons (30 ml) oil to pot and brown remaining beef. Transfer to platter. Reduce heat to medium low. Add bacon and cook until crisp. Using a slotted spoon, transfer bacon to paper towels. Pour off all but 1 tablespoon bacon fat. Melt 2 tablespoons (30 g) butter in same pot. Add reserved vegetables and sauté until slightly browned. Use slotted spoon to transfer vegetables to platter. Pour Port into pot, stirring with a wooden spoon to scrape up browned bits. Add reserved wine marinade, broth, tomato paste, 1 teaspoon salt and ½ teaspoon pepper into pot and stir well. Increase heat to medium high and bring to boil. Continue cooking 15 minutes. Reduce heat to low.

Preheat oven to 300 F (150 C). Blend remaining 2 tablespoons (30 g) butter and flour in small bowl until paste forms. Add to liquid in pot and whisk until thickened, about 3 minutes. Return beef, vegetables and bacon to pot. Transfer pot to oven and cook for 2 ½ hours until fork tender but not falling apart. Season with salt and pepper. Transfer to a 9 x 13-inch (23 cm x 33 cm) baking dish. *(Can be prepared 1 day ahead. Cover and refrigerate. Heat through before topping with pastry and continuing with recipe.)*

Lightly flour work surface. Roll out puff pastry sheet to at least a 10 x 14-inch (25 cm x 35 cm) rectangle. Drape pastry over beef filling and pinch to seal edges with dish. Using a sharp knife, cut several vents in pastry to release steam. Sprinkle with dried rosemary. Bake until crust is golden brown, 20 to 25 minutes. Let rest several minutes before serving.

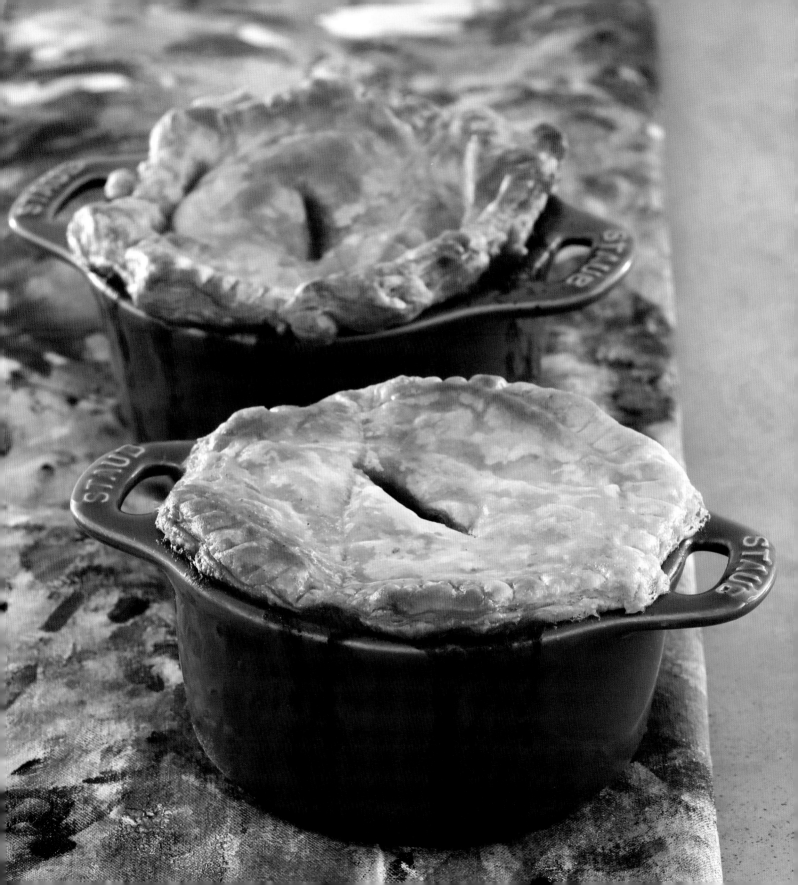

Roasted Cod with Fresh Corn, Red Pepper, Onion and Caper Salad

6 MAIN COURSE SERVINGS

CORN SALAD

6 large ears corn, shucked

1 cup (175 g) diced red bell pepper

½ cup (75 g) diced red onion

1 tablespoon capers,
rinsed and drained

6 tablespoons (90 ml)
extra virgin olive oil

2 tablespoons (30 ml)
fresh lemon juice

1 ½ teaspoons caper juice

½ teaspoon sea salt

¼ teaspoon freshly ground pepper

COD

6 (6- to 8-ounce) (170 g to
225 g) skinless cod fillets

1 tablespoon (15 ml) olive oil

¼ teaspoon dried
oregano, crumbled

¼ teaspoon garlic powder

Salt and freshly ground pepper

One of Monet's favorite dishes was a cod recipe provided by Cezanne, who lived near Marseilles in the South of France but often summered in the picturesque village of La Roche Guyon, close to Giverny. If you visit there today to view the ruined castle and restored chateau that Cezanne painted, be sure to visit the chateau's walled kitchen garden beside the River Seine. It is one of the largest in Normandy, featuring vegetables and fruits in a formal layout similar to Monet's kitchen garden. For the cod we thought to use a modern composition bursting with flavor. The contrast of the warm, meaty yet delicate fish with the cool, crisp salad is refreshing and delicious. The corn salad would be wonderful alongside almost any other simply roasted or grilled meat, fish or fowl. Or, for a vegan option, try tossing the salad with pasta, rice or a grain such as quinoa, farro or barley. Serve with a chilled dry alcoholic apple cider, a true French Chablis (no imposters!), or a lightly oaked Chardonnay.

FOR CORN SALAD: Bring a large pot of salted water to boil. Add corn and cook 3 minutes. Meanwhile, prepare a large bowl of ice water. Drain corn and add to ice water to stop cooking and preserve color. Pat corn dry with paper towels. Cut kernels off cobs, cutting close to cobs. Place corn in a large bowl. Add pepper, onion and capers. Whisk together olive oil, lemon juice, caper juice, salt and pepper in a small bowl. Pour over corn mixture and toss well. Cover and refrigerate until ready to serve.

FOR COD: Preheat oven to 400 F (200 C). Pat cod dry with paper towels. Brush a 9 x 13-inch (23 cm x33 cm) baking dish with olive oil. Place cod in prepared baking dish and turn to coat both sides of cod with oil. Sprinkle cod with oregano and garlic powder. Season with salt and pepper. Roast until cod flakes easily with fork, about 10 minutes.

TO SERVE: Using a slotted spatula, transfer cod to plates. Divide corn salad among plates. Serve immediately.

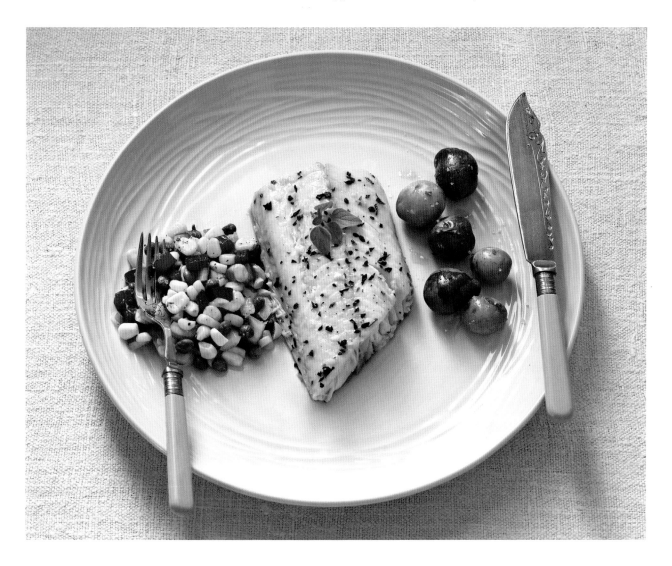

Grilled Lamb Chops with Parsley and Mint Vinaigrette

6 MAIN COURSE SERVINGS

⅓ cup (80 ml) malt vinegar
or red wine vinegar

1 tablespoon Dijon mustard

1 tablespoon minced shallot

1 teaspoon (7 g) honey

½ teaspoon salt, plus more
for seasoning chops

½ teaspoon freshly ground pepper,
plus more for seasoning chops

¼ cup (60 ml) extra virgin olive
oil, plus more for brushing chops

¼ cup (60 ml) canola or
other vegetable oil

¼ cup (60 ml) chopped
fresh parsley

¼ cup (60 ml) chopped mint

12 lamb rib chops, about 3
ounces (90 g) each, trimmed

The countryside around Giverny is still mostly rural, so sourcing fresh cuts of meat such as lamb chops was never a problem for Monet. In fact, the meadow beyond his water garden was and still is a sheep pasture. Every year, Monet grew a patch of mint in his kitchen garden. Lamb with mint jelly is a classic combination, and in this surprisingly easy yet sophisticated dish we have updated the marriage for modern tastes. Monet would have eaten his lamb with new potatoes and haricots verts or green peas. You could pour a Bordeaux, Monet's favorite wine, or any other dry red wine.

Preheat a large grill pan over high heat. Place vinegar, mustard, shallot, honey, ½ teaspoon salt and ½ teaspoon pepper in medium-size bowl and whisk well to blend. Whisk in olive oil in a slow, steady stream, then whisk in vegetable oil. Whisk in parsley and mint. Set vinaigrette aside; do not refrigerate. Brush lamb chops with olive oil. Season generously with salt and pepper. Place chops on prepared grill and cook to desired degree of doneness, 4 to 5 minutes for medium rare, turning once midway through. Let chops rest a few minutes. Place 2 chops on each plate. Pass vinaigrette separately.

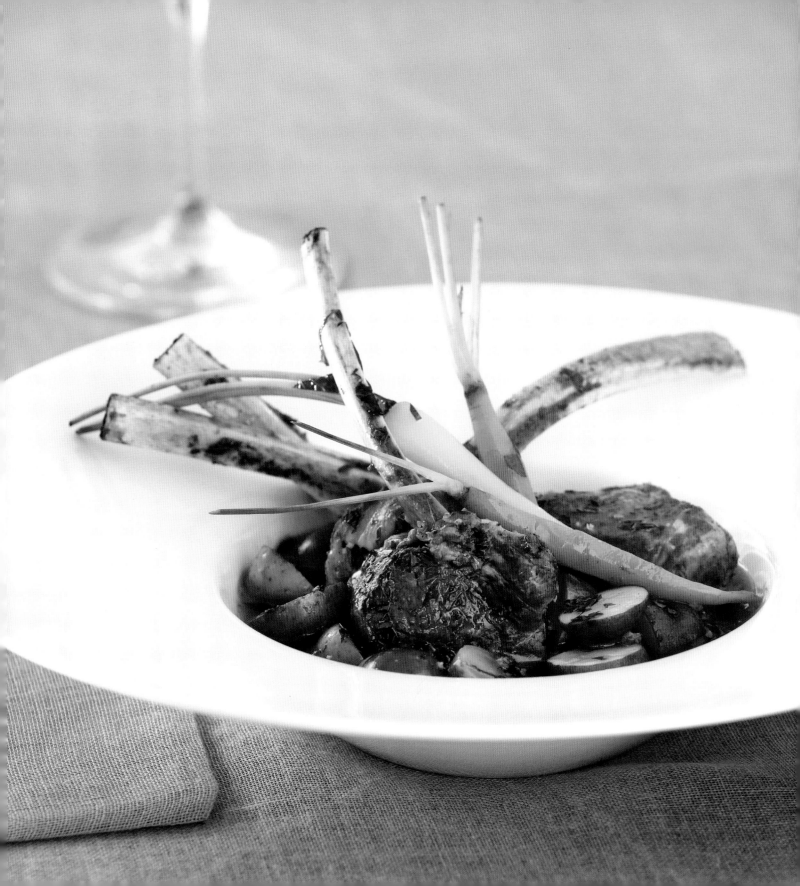

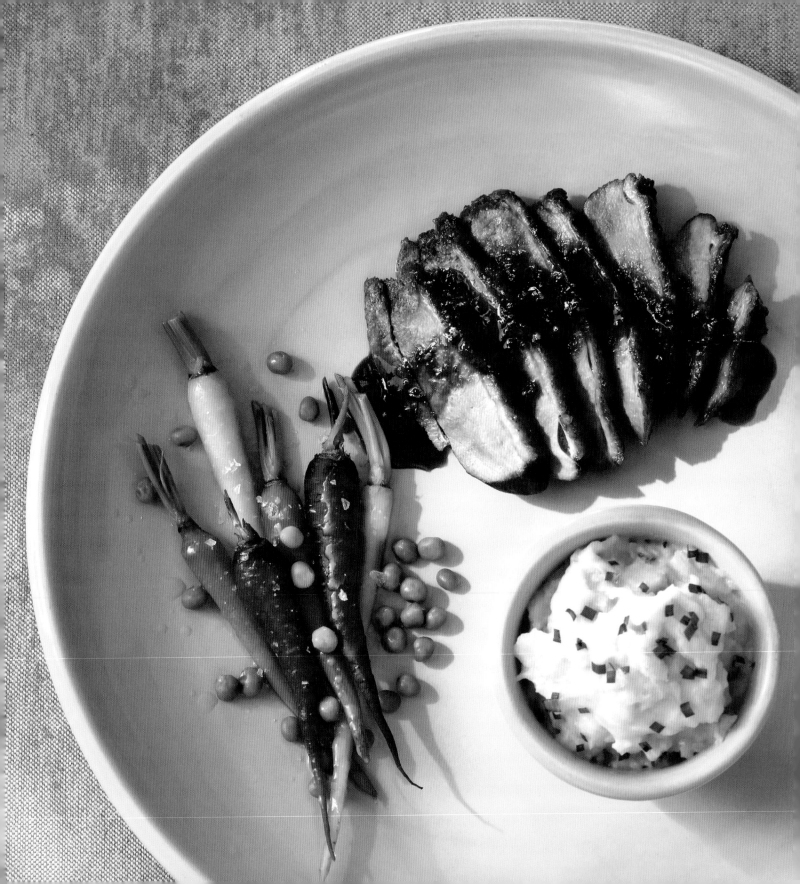

Crispy Duck Breasts with Berry and Orange Glaze, Mashed Potatoes and Peas and Carrots

4 MAIN COURSE SERVINGS

GLAZE

¹/₄ cup (80 g) raspberry preserves or jam, strained

2 tablespoons (40 g) strawberry preserves or jam, strained

¹/₄ cup (80 g) orange marmalade, strained

2 tablespoons (30 ml) balsamic vinegar

1 teaspoon onion powder

1 teaspoon peeled and grated ginger

¹/₄ teaspoon salt

¹/₄ teaspoon freshly ground pepper

Here duck is cooked to perfection in a dish that surely would have pleased Monet, as he was a huge fan of the bird—so much so that he maintained his own flock. He raised several breeds and constructed a small pond adjacent to his farmyard. He would have loved the sweet-tart berry and orange glaze on the duck breasts, which is also delicious on chicken, turkey, pork or lamb. While we call for shelling peas, also known as English peas, the edible-pod variety named sugar snap would be a delicious substitute. Monet was particularly fond of those known in French as *mangetout*, which translates as "eat everything," so called because the entire pod is consumed. Pair this elegant dinner with a wine with good acidity, such as a white Alsatian Riesling, a red Pinot Noir or a light-bodied red Burgundy.

FOR GLAZE: Combine preserves, marmalade and vinegar in a small heavy saucepan over low heat and cook until mixture liquefies, stirring often. Add onion powder, ginger, salt and pepper and continue cooking, stirring continuously, until mixture reduces and thickens enough to coat the back of a spoon, about 10 minutes. Set aside until ready to use. *(Can be prepared 1 day ahead. Cover and refrigerate. Bring to room temperature before continuing with recipe.)*

(continued)

MASHED POTATOES

2 pounds (450 g) red new
potatoes, peeled and quartered

1/4 cup (60 ml) whipping
or heavy cream

10 tablespoons (1 1/4 sticks) (150
g) butter, chilled, divided

1 teaspoon dried
rosemary, crumbled

1/2 teaspoon salt

1/4 teaspoon freshly ground pepper

Whole milk, optional

PEAS AND CARROTS

3 tablespoons (45 g) unsalted butter

2 pounds (900 g) small farmers'
market carrots, peeled, trimmed
and blanched until just tender

2 cups (300 g) shelled fresh
green peas or 1 pound
(450 g) frozen, thawed

1 tablespoon (20 g) honey

1/2 teaspoon salt

DUCK

4 boneless, skin-on duck breast
halves (about 1 1/2 pounds (700 g),
preferably Moulard (also known
as "magrets de canard") or Pekin
(or Long Island)

Salt and freshly ground pepper

2 fresh parsley sprigs, minced

FOR MASHED POTATOES: Bring a large pot of salted water to boil. Add potatoes and boil until tender when pierced with a knife. Meanwhile, bring cream just to boil in a small heavy saucepan over low heat. Drain potatoes and return to pot. Gradually add 8 tablespoons (120 g) butter and mash potatoes well. Gradually stir in warm cream. Stir in remaining 2 tablespoons (30 g) butter. Stir in rosemary, salt and pepper. Adjust seasoning with additional salt and pepper if desired. *(Can be prepared 1 day ahead. Cover and refrigerate. Before serving, reheat potatoes over very low heat, adding milk to thin if necessary.)*

FOR PEAS AND CARROTS: Melt butter in a large heavy skillet over medium heat. Add carrots and peas and sauté until heated through and well coated with butter. Add honey and salt and stir well. Cover and keep warm until ready to serve.

FOR DUCK: Preheat oven to 350 F (180 C). Using a very sharp knife, score skins of duck breasts; get as close to flesh as possible without puncturing. Season duck breasts with salt and pepper. Preheat a large heavy skillet over medium heat. Place duck breasts skin side down in skillet and cook until skin is crisp and fat is rendered, 8 to 10 minutes. Transfer duck breasts, skin side up, to a baking sheet. Brush skin with glaze. Bake until glaze has set, 2 to 3 minutes. Remove from oven and brush skin again with glaze. Bake until duck flesh is medium rare, 5 to 8 minutes, or longer if more well-done duck is preferred. Transfer duck breasts to a cutting board and let rest 5 minutes.

TO SERVE: Slice each duck breast on diagonal and fan slices out, including skin, on dinner plates. Gently reheat mashed potatoes and peas and carrots if necessary; sprinkle parsley over peas and carrots. Divide potatoes and peas and carrots among plates. Serve immediately.

Roast Pork with Cherry Sauce

6 MAIN COURSE SERVINGS

1 tablespoon olive oil

1 (3-pound) (1,350 kg) boneless pork loin; do not trim off fat

1 tablespoon dried thyme, crumbled

Salt and freshly ground pepper

2 cups (450 g) fresh sweet cherries, pitted and halved, or 2 cups (520 g) frozen pitted black cherries, defrosted and halved

1/2 cup (120 ml) dry red wine

1 tablespoon orange marmalade

1 1/2 teaspoons sugar

1 garlic clove, minced

1/8 teaspoon salt

1/8 teaspoon freshly ground pepper

Helen Rappel Bordman has been an American representative at Giverny since the time of its restoration in 1980. She still spends each spring in her apartment on the property and recalls three huge cherry trees in the flower garden. Each year the museum guards would climb the trees to present her with the tart-sweet red 'Montmorency' cherries as a gift. The fruit from these trees (since removed when they became overgrown) went into Monet's brandied cherries, for which his cook, Marguerite, was famous. The closest town, Vernon, has an annual cherry festival! Roast pork is a Norman favorite. Usually it is accompanied by an apple cream sauce, but here we offer an especially delicious cherry sauce as an homage to the beloved trees. (The low cooking temperature is correct; it results in super-moist meat.) Serve it with buttered noodles or wild rice and pour a dry red wine of your choice.

Preheat oven to 450 F (230 C). Rub olive oil all over pork. Rub thyme all over pork. Season pork generously with salt and pepper. Place pork fat side up on a rack in a roasting pan. Roast 10 minutes. Reduce heat to 250 F (120 C). Continue roasting pork until meat thermometer registers 140 F (60 C), 50 to 80 minutes depending on length and thickness of pork. Cover with foil and let rest 15 minutes; temperature should increase by about 5 degrees.

Meanwhile, place cherries, wine, marmalade, sugar, garlic, salt and pepper in a medium-size heavy nonreactive saucepan and bring to boil. Reduce heat and simmer until slightly reduced, 10 to 12 minutes, stirring occasionally. Transfer to a serving bowl.

Cut roast into slices. Pass sauce separately.

Bouillabaisse with Aïoli

8 MAIN COURSE SERVINGS

BOUILLABAISSE

½ cup (120 ml) olive oil

1 ½ cups (150 g) chopped leeks, white and light-green parts only

½ cup (75 g) chopped onion

3 cups (600 g) chopped tomato

2 cups (450 g) tomato puree

½ cup (15 g) chopped fresh Italian parsley

2 tablespoons fresh thyme sprigs tied with kitchen twine

2 bay leaves

4 cups (1 l) fish stock or clam juice

2 cups (480 ml) dry white wine

Salt and freshly ground pepper

6 tablespoons (¾ stick) (90 g) unsalted butter, room temperature

2 teaspoons (15 g) all-purpose flour

1 ½ teaspoons saffron threads

2 quarts (2 l) mussels, debearded

40 littleneck clams

4 pounds (1,8 kg) lobster tails, shelled and halved lengthwise

3 pounds (1,4 kg) firm white fish (such as halibut, cod or snapper), skinned and cubed

32 raw shrimp, shelled and deveined

Bouillabaisse is the classic fish stew from Marseilles, on the Mediterranean coast. Preparations vary from one port town to the next, but what they have in common is local seafood ingredients cooked in white wine flavored with tomatoes, garlic, parsley, saffron, pepper and bay leaves. The fish used is usually cod or red mullet, accompanied by spiny lobster, crab, prawns and clams. Both Cezanne and Renoir provided Monet with their favorite bouillabaisse recipes. Although the precise ingredients for these are not now known, famous French chef Michel Richard, owner of French restaurants in Washington, D.C., and New York City, has provided us with his favorite Bouillabaisse recipe. Pour a Provençal rosé.

FOR BOUILLABAISSE: Heat olive oil in a large heavy pot or casserole over medium heat. Add leeks and onion and sauté until onion is translucent, about 10 minutes. Stir in tomato, tomato puree, parsley, thyme and bay leaves. Pour in fish stock and wine and stir well. Season with salt and pepper. Bring to gentle boil, reduce heat and simmer 20 minutes.

Blend butter and flour into paste in a small bowl. Add to tomato mixture and stir well. Stir in saffron. Add mussels and clams and simmer 5 minutes. Add lobster, fish and shrimp and simmer until mussel and clam shells have opened, but no longer; do not overcook. Discard any mussels and clams that do not open when tapped.

AÏOLI

2 (4- to 5-ounce) (100 g à 140 g) Yukon Gold Potatoes, peeled and cut into ¹/₂-inch (1,5 cm) cubes

8 garlic cloves

2 large egg yolks

2 cups (480 ml) extra virgin olive oil

Fresh lemon juice

Fine sea salt

Cayenne pepper

Crusty bread

FOR AÏOLI: Boil or steam potatoes until completely tender when pierced with knife. Transfer potatoes to food processor. Grate garlic cloves directly into a food processor. Add yolks and a bit of olive oil and process until mixture is smooth. With machine running, slowly drizzle in remaining olive oil to form mayonnaise-textured mixture. Season to taste with a few drops lemon juice, salt and cayenne pepper. Transfer to a serving bowl. *(Can be prepared 1 day ahead. Cover and refrigerate. Bring to room temperature before serving.)*

TO SERVE: Ladle bouillabaisse into bowls, dividing seafood evenly. Serve immediately with crusty bread and aïoli.

Gratin of Turbot, Carrots and Leeks with Cider and Cream

4 MAIN COURSE SERVINGS

WHITE SAUCE

1 cup (240 ml) whole milk

8 tablespoons (120 g) butter, divided

2 tablespoons (15 g) all-purpose flour

3 egg yolks

Salt and freshly ground pepper

FISH AND VEGETABLES

2 tablespoons (¹/₄ stick) (30 g) butter

³/₄ pound (350 g) carrots, peeled and julienned

2 large leeks, julienned, white and light-green parts only

1 cup (240 g) crème fraîche

Salt and freshly ground pepper

¹/₃ cup (80 ml) dry alcoholic apple cider

4 turbot or halibut fillets

Turbot is a delicious flatfish which is very popular in France. Here Chef Maurice Amiot takes the fish and nestles it on a bed of sautéed carrots and leeks (both were grown in Monet's kitchen garden) tossed with crème fraîche and drizzled with apple cider (both traditional ingredients in Normandy). Then he covers everything with a rich cream sauce—made with the outstanding butter, milk and eggs of the region—that gets broiled until browned and bubbly. This decadent seafood creation needs nothing more than a green salad before or after. Pour a chilled white wine such as sauvignon blanc, or choose the apple cider with which you cooked.

FOR SAUCE: Place milk in a small heavy saucepan and bring to boil over medium heat. Melt 4 tablespoons (60 g) butter in a medium-size heavy saucepan over medium heat. Whisk in flour and continue whisking a few minutes. Gradually whisk in hot milk; return to boil. Remove pan from heat. Whisk in remaining 4 tablespoons (60 g) butter. Whisk in egg yolks. Season sauce with salt and pepper. Transfer sauce to a bowl.

FOR FISH AND VEGETABLES: Preheat oven to 350 F (180 C). Melt butter in a large heavy skillet over medium heat. Add carrots and leeks and sauté until slightly softened, about 10 minutes. Stir in crème fraîche. Season with salt and pepper. Transfer vegetable mixture to a large shallow baking dish or gratin pan. Drizzle with cider. Top with fish fillets. Cover fish with sauce. Bake until fish is cooked through, 15 to 20 minutes. Increase heat to broil and broil until sauce is gently browned. Serve immediately.

Camembert Scrambled Eggs with Tomato and Chives Topped with Asparagus and Morel Mushroom Sauté

ASPARAGUS AND MOREL MUSHROOM SAUTÉ

1 large bunch (about 1 pound) (450 g) asparagus, trimmed, peeled if woody, and cut diagonally into 1-inch (2,5 cm) pieces

3 tablespoons (45 g) unsalted butter

1 tablespoon (15 ml) extra virgin olive oil

2 small garlic cloves, minced

4 ounces (110 g) fresh morel mushrooms, brushed clean and quartered (*if not available, substitute another fresh wild mushroom or rehydrated dried morels*)

¹/₄ teaspoon salt

¹/₄ teaspoon freshly ground pepper

Fluffy eggs enriched with Camembert cheese—a favorite of Monet's—and crème fraîche make for a decadently delicious brunch, lunch or supper dish when paired with the classic French combination of asparagus and morel mushrooms. At the Tuesday market in nearby Vernon, local vendors sell the famous Normandy cheese called Camembert, as well as morel mushrooms gathered from the nearby woodlands, and both green and sweet white asparagus. Monet raised his own free-range chickens, which provided eggs with a brilliant orange-colored yolk. Just add a salad, some crusty bread and a light-bodied red wine such as Beaujolais or Grenache.

FOR SAUTÉ: Fill a large bowl with ice and water. Set aside. Bring a large pot of salted water to boil. Add asparagus pieces and cook until just fork tender, about 2 minutes. Drain and transfer to ice water to stop cooking and set color. Drain asparagus and pat dry. Melt butter with olive oil in a large heavy skillet over medium heat. Add garlic and stir until slightly golden, about 1 minute; do not burn. Add asparagus and morels and sauté until mushrooms are tender and begin to caramelize, about 10 minutes. Stir in salt and pepper. *(Can be prepared 1 day ahead. Cover and refrigerate. Reheat before serving.)*

(continued)

SCRAMBLED EGGS

12 large eggs

3 tablespoons (45 g) unsalted butter

4 ounces (110 g) Camembert
or Brie cheese, rind
removed, cut into cubes

3 tablespoons (45 g) crème fraîche

4 plum tomatoes, diced

3 tablespoons (10 g) snipped chives

1/4 teaspoon salt

1/4 teaspoon freshly ground pepper

FOR EGGS: Break eggs into a large bowl; do not whisk or season. Melt butter in a large heavy skillet over low heat. Pour eggs into skillet, stirring gently with spatula to break yolks. Continue cooking and stirring until eggs begin to set. Stir in cheese 1 piece at a time, dispersing cheese throughout eggs, and cook and stir until evenly melted. Stir in crème fraîche. Remove pan from heat. Fold in tomatoes and chives. Stir in salt and pepper.

TO SERVE: Divide eggs among 4 plates. Spoon asparagus mixture over eggs. Serve immediately.

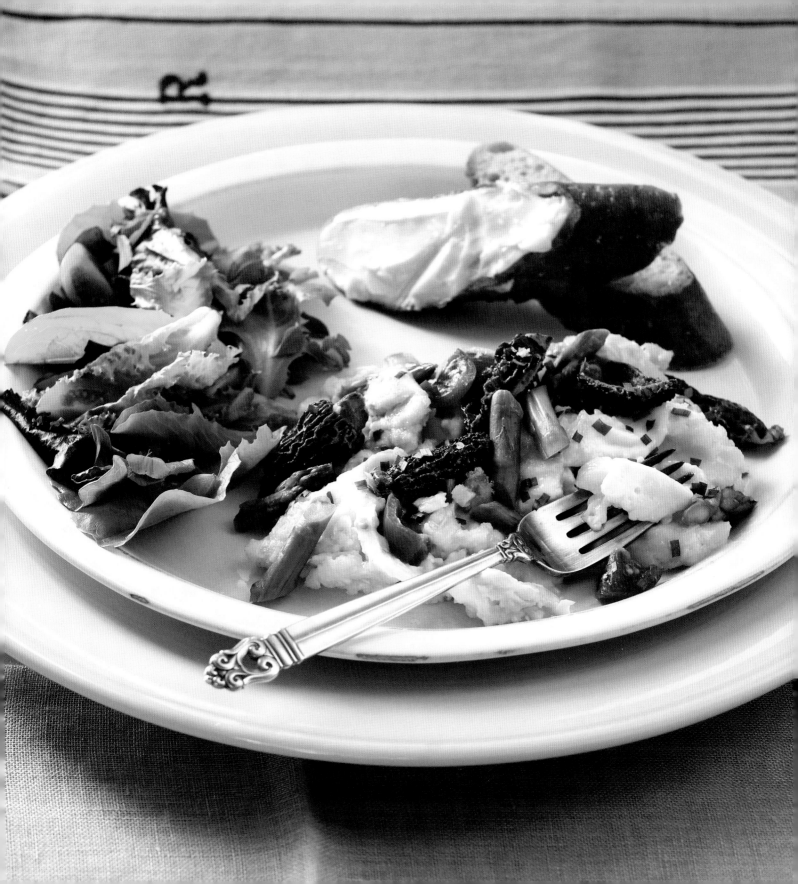

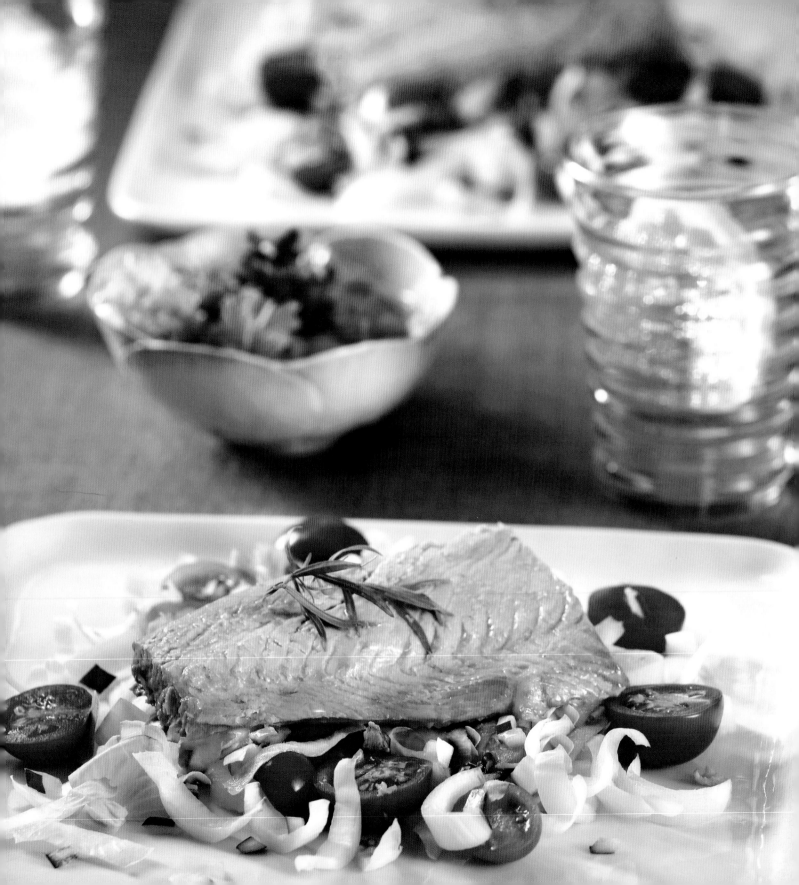

Cold Poached Salmon with Endive, Tomato and Red Onion Salad

6 MAIN COURSE SERVINGS

2 cups (480 ml) water

1 cup (240 ml) dry white wine

1 tablespoon (15 ml) fresh lemon juice

2 garlic cloves, halved

1 teaspoon dried dill

½ teaspoon salt

6 (6-ounce) (170 g) skinless and boneless salmon fillets

1½ tablespoons (30 g) honey

1 tablespoon Dijon mustard

1 tablespoon fresh lemon juice

1 tablespoon capers, drained and rinsed

1 teaspoon minced shallot

¼ teaspoon salt, plus more for seasoning

¼ teaspoon freshly ground pepper, plus more for seasoning

¼ cup (60 ml) extra virgin olive oil

3 large green Belgian endives, trimmed, outer leaves removed and thinly sliced

1 cup (150 g) halved cherry tomatoes

¼ cup (25 g) thinly sliced red onion

1 tablespoon chopped fresh chervil

Monet's passion for the seacoast, the River Seine and the streams of Normandy was matched by his love for the fisherman's catch. Seafood had pride of place at his dining table, including salmon, a fish he learned to love on his trips to visit his son in Norway. The French adore Belgian endive, both raw and cooked, and Monet was no exception. He grew it in the basement of his Blue House, since the blanched chicons must be grown in the dark. The cherry tomatoes he grew outdoors. Here the two join forces in a refreshing salad filled with flavor and topped with simply poached salmon. Serve for lunch or supper accompanied by crusty bread, and pour a fruit fumé blanc or chenin blanc.

Place water, wine, lemon juice, garlic, dill and salt in a large heavy skillet and bring to boil. Reduce heat to simmer. Arrange salmon in single layer in skillet and simmer gently until slightly firm to touch, about 10 minutes. Using a slotted spatula, transfer salmon to platter and pat dry. Refrigerate until cold. *(Can be prepared 1 day ahead.)*

Place honey, mustard, lemon juice, capers, shallot, salt and pepper in a small bowl and whisk to combine. Whisk in olive oil in slow steady stream. Place endives, tomatoes, onion and chervil in a large salad bowl. Add dressing and toss well to combine. Adjust seasoning with additional salt and pepper.

Divide salad among 6 plates. Top each with salmon fillet. Serve immediately.

Baked Cheese-Stuffed Portobello Mushrooms with Herbed Tomato Sauce

6 MAIN COURSE SERVINGS

SAUCE

3 tablespoons (45 ml) extra virgin olive oil

2 large garlic cloves, minced

1 (28-ounce) (800 g) can whole peeled San Marzano tomatoes, drained and chopped

¼ cup (6 g) chopped fresh parsley

1 teaspoon dried oregano, crumbled

Salt and freshly ground pepper

2 teaspoons chopped fresh basil

Monet had two sources of mushrooms for his table: the cellar of his Blue House, where the resident gardener grew button mushrooms in the basement, and the meadows and woodlands surrounding his property, where wild mushrooms such as chanterelles and morels could be harvested in season. The white button mushroom, native to grasslands of Europe (especially where horses have pastured), has been cultivated for centuries in special darkened rooms and caves. Its cousin, the cremini mushroom, is simply a whole button mushroom with brown skin, and the portobello is simply a mature cremini. Here this large, meaty, disc-shaped mushroom is stuffed with a vegetarian filling bursting with aromatic vegetables, herbs and cheese (for a vegan version, use a vegan cheese and omit the egg) and accompanied by an easy tomato sauce alive with fresh basil. Monet grew a basil variety called lettuce leaf, with broad, shiny, spear-shaped leaves; today we have many other options available. This hearty dish calls for an equally hearty dry red wine. Try a Burgundy, Zinfandel or Cabernet.

FOR SAUCE: Heat olive oil in a medium-size heavy saucepan over medium heat. Add garlic and sauté until golden, about 1 minute; do not burn. Add tomatoes and simmer 5 minutes. Add parsley and oregano and simmer until sauce has thickened. Season with salt and pepper. Stir in basil. *(Can be prepared 1 day ahead. Cool, cover and refrigerate. Reheat before serving.)*

MUSHROOMS

3 tablespoons (45 ml) extra virgin olive oil

2 tablespoons (20 g) minced shallots

3/4 cup (130 g) diced red pepper

1/4 cup (25 g) diced celery

1/2 teaspoon salt, plus more for seasoning

1 teaspoon freshly ground pepper

1/4 cup (60 ml) sweet Port

12 large brown cremini or white button mushrooms, brushed clean, stems discarded, caps finely chopped

1/3 cup (30 g) dry breadcrumbs

2 tablespoons chopped fresh Italian parsley

1 teaspoon dried basil, crumbled

1 egg yolk

2 cups (about 8 ounces) (225 g) freshly grated Gruyère cheese

6 large portobello mushrooms (about 2 pounds) (900 g) brushed clean, stems and gills removed

3 tablespoons (15 g) panko (Japanese breadcrumbs)

2 tablespoons freshly grated Parmesan cheese

FOR MUSHROOMS: Preheat oven to 375 F (190 C). Lightly grease a shallow baking dish big enough to hold portobellos. Heat olive oil in a large heavy skillet over medium heat. Add shallots and stir until translucent. Add red pepper, celery and 1/2 teaspoon salt and sauté until vegetables are soft, about 15 minutes. Stir in pepper. Remove pan from heat. Stir in Port; do not add on heat or Port will flame. Return pan to medium heat and stir to deglaze pan. Add chopped mushrooms and sauté until most of liquid is exuded, about 5 minutes. Transfer mixture, including liquid, to a large bowl. Stir in breadcrumbs, parsley and basil. Let cool. Stir in yolk. Season with additional salt. Fold cheese into stuffing. Divide stuffing among portobello mushroom caps, mounding well. Arrange stuffed mushroom caps in prepared dish. Sprinkle with panko, then Parmesan. Bake until mushrooms are cooked, stuffing is hot and top is golden brown, 15 to 20 minutes.

TO SERVE: Place 1 stuffed mushroom cap on each plate. Spoon some sauce on side, passing remaining sauce separately. Serve immediately.

Roast Beef and Yorkshire Pudding with Gruyère and Herbs

6 TO 8 MAIN COURSE SERVINGS

2 ½ cups (600 ml) whole milk, room temperature

4 large eggs, room temperature

1 cup (120 g) all-purpose flour

1 teaspoon salt

¼ teaspoon freshly ground pepper

¼ teaspoon dried rosemary, crumbled

6 tablespoons (40 g) freshly grated Gruyère cheese, room temperature

1 tablespoon chopped fresh flat-leaf parsley

1 (3 ½-pound) (1,6 kg) boneless rib-eye roast, trimmed and tied at 2-inch intervals

Salt and freshly ground pepper

8 teaspoons (120 ml) vegetable oil, optional

½ cup (120 ml) low-sodium beef stock or broth

Monet loved London and visited the city often to paint. While there he dined frequently in the restaurant of the Savoy Hotel, where the esteemed chef Auguste Escoffier, the father of modern French cuisine, reigned in the kitchen. Monet was particularly fond of this version of Yorkshire pudding, so much so that he insisted that his cook, Marguerite, try to duplicate it at Giverny. We serve this as it was served at the Savoy: with roast beef. However, it would also be a delicious accompaniment to roast pork or lamb. Alternatively, make the Yorkshire pudding in its own juices and serve it with a mixed green salad for a lovely vegetarian brunch, lunch or supper. With meat, uncork a robust red wine such as Cabernet Sauvignon; without meat try a white such as Sauvignon Blanc.

Pour milk into a medium-size bowl. Add eggs and whisk well. Gradually whisk in flour, 1 teaspoon salt, ¼ teaspoon pepper and rosemary and continue whisking until batter is airy. Fold in cheese and parsley. Cover and let stand in cool place 1 hour.

Preheat oven to 425 F (220 C). Season roast generously with salt and pepper. Place roast fat-side up on a rack in a roasting pan. Roast until meat thermometer inserted in thickest part of meat reads 120 to 125 F (49 C to 52 C) for rare, about 20 minutes; 130 to 135 F (55 C to 57 C) for medium-rare, about 25 minutes; or 135 to 140 F (57 C to 60 C) for medium, about 30 minutes.

Transfer roast to a platter. Tent roast loosely with foil. Let stand 20 to 30 minutes. Pour off beef drippings from pan and reserve drippings. Do not wash roasting pan.

Meanwhile, reduce oven temperature to 400 F (200 C). Spoon 1 teaspoon beef drippings or vegetable oil in the bottom of each of 8 cups of 12-cup nonstick muffin tin. Place in oven until liquid is heated. Ladle batter into prepared muffin cups, filling each just halfway. Bake until puddings have risen and are golden brown around edges, about 30 minutes.

Meanwhile, place roasting pan over medium heat. Pour in stock and bring to boil, scraping bottom of pan with a wooden spoon to bring up browned bits. Season with salt and pepper. Keep *jus* warm over low heat.

Cut roast into slices. Place 1 slice of roast and 1 Yorkshire pudding on each plate. Pass jus separately.

Omelet with Goat Cheese and Fresh Herbs

4 MAIN COURSE SERVINGS

4 ounces (110 g) fresh goat cheese, room temperature

4 ounces (110 g) farmer's cheese, room temperature

1 garlic clove, minced

1 1/2 teaspoons minced fresh oregano or 1/2 teaspoon dried, crumbled

1 1/2 teaspoons minced fresh basil or 1/2 teaspoon dried, crumbled

1 1/2 teaspoons minced fresh thyme or 1/2 teaspoon dried, crumbled

1/4 teaspoon onion powder

Salt and freshly ground pepper

12 large eggs, room temperature, divided

6 tablespoons (90 g) salted butter, divided

1/2 cup (15 g) chopped fresh parsley, divided

Strawberry jam

Monet was a fan of the oversized soufflé-style omelets at the restaurant La Mère Poulard on Mont St. Michel in upper Normandy. At the restaurant, established in 1879 and still in existence today, the chef beats the eggs in hand-hammered copper bowls and cooks them over an open fire. While these types of omelets are generally left to restaurants to prepare, a simple folded omelet is a classic country French lunch or supper dish, as beloved in Normandy—where the eggs are exquisite—as in the rest of the country. We have filled this one with goat cheese—readily available in Normandy and a fixture of Monet's larder—mixed with fresh herbs from the garden. We suggest accompanying the omelet with strawberry jam. You will be surprised how deliciously the fruit pairs with the eggs and cheese. Serve with a green salad and crusty bread and pour a Beaujolais, Beaujolais-Villages or Gamay.

Place both cheeses, garlic, herbs and onion powder in bowl. Using a wooden spoon, mix well. Season with salt and pepper. *(Can be made 1 day ahead. Cover and refrigerate.)*

Preheat oven to 200 F (95 C). Place 3 eggs in small bowl. Using a fork, beat eggs until yolks and whites are well mixed. Melt 2 tablespoons butter in a 10-inch (25 cm) omelet pan or heavy skillet over medium-low heat. When butter sizzles, pour eggs into pan and tilt so eggs cover bottom of pan. Allow eggs to cook until almost set. Spoon 1/4 of filling down center of omelet. When cheese has melted, fold both sides of omelet in over filling in center. Remove from heat. Transfer to an ovenproof plate or platter. Keep warm in oven. Repeat to make 4 omelets.

Place 1 omelet on each plate. Sprinkle with parsley. Accompany with jam.

Moussaka for Monet

6 MAIN COURSE SERVINGS

3 tablespoons (45 ml) olive oil

1 cup (150 g) finely chopped onion

1 teaspoon ground cinnamon

1 teaspoon freshly ground pepper, plus more for seasoning

1/2 teaspoon salt, plus more for seasoning

3 cups (225 g) sliced cremini mushrooms

4 garlic cloves, chopped

1 (28-ounce) (800 g) can whole peeled tomatoes

1/4 cup (60 g) tomato paste

1/4 cup (60 ml) water

1 tablespoon dried oregano, crumbled

2 large eggplants, cut lengthwise into 3/8-inch (1 cm)-thick slices

2 cups (500 g) nonfat Greek yogurt

4 ounces (110 g) feta cheese, crumbled

1 large egg

2 tablespoons grated Parmesan cheese

1/4 teaspoon ground nutmeg

1 tablespoon chopped fresh mint, plus more for garnish

Monet's cook, Marguerite, would often layer slices of garden-fresh eggplant and tomato in a rustic baking dish, drizzle the vegetables with olive oil and bake them for a simple side dish. Here we take those two ingredients and incorporate them into our rendition of the classic Greek dish moussaka, which is popular throughout France. We use mushrooms rather than meat for a vegetarian version, but you could certainly use ground lamb or beef instead. Serve the moussaka with a Greek salad and pita bread, or offer it as an accompaniment to roast lamb. Pour a Greek wine if you can find one—there are many good white and red options nowadays.

Heat oil in a large heavy skillet over medium heat. Add onion, cinnamon, 1 teaspoon pepper and 1/2 teaspoon salt and sauté until onions are slightly caramelized, about 10 minutes. Add mushrooms and garlic and sauté until mushrooms are slightly browned, about 10 minutes. Add tomatoes and their liquid; break up tomatoes with a spoon. Stir in tomato paste, water and oregano and bring to boil. Reduce heat and simmer until thick, about 1 hour, stirring occasionally. Set aside until ready to use.

Meanwhile, place eggplant slices on a baking sheet. Sprinkle with salt and let stand 30 minutes.

Preheat oven to 350 F (180 C). Drain off liquid from eggplant. Using a towel, pat eggplant slices dry. Arrange eggplant slices on a nonstick baking sheet. Broil until eggplant is brown, about 2 minutes per side. Arrange some eggplant slices on the bottom of a 9 x 13-inch (23 cm x 33 cm) baking dish. Cover with $\frac{1}{2}$ of mushroom mixture. Top with another layer of eggplant slices. Cover with remaining mushroom mixture. Top with layer of remaining eggplant slices. Place yogurt, feta, egg, Parmesan, 1 tablespoon mint and nutmeg in a medium-size bowl. Season with salt and pepper if necessary. Whisk well to combine. Spoon mixture over eggplant. Bake 30 minutes. Increase oven temperature to 400 F (200 C) and continue baking until top starts to brown, about 10 minutes. Remove from oven and immediately sprinkle with nutmeg. Let set 5 to 10 minutes before cutting into 6 squares. Set each square on a plate. Sprinkle with mint and serve.

Pasta with Broccoli, Brown Butter and Sage

**4 MAIN COURSE OR 6
SIDE DISH SERVINGS**

3/4 pound (about 1 small
head) (350 g) broccoli, stalk
discarded, cut into florets

1 tablespoon fresh lemon juice

1/2 pound (225 g) penne
or other short pasta

6 tablespoons (90 g) unsalted butter

8 large sage leaves

1/4 cup (25 g) freshly
grated Parmesan cheese,
plus more for serving

Salt and freshly ground pepper

1 tablespoon chopped
fresh flat-leaf parsley

Red pepper flakes

Monet spent time painting on the French and Italian Rivieras. His canvases reflect the inspiration he found in the color and light of those picturesque waterfront regions. He would begin the day at the local farmers' markets to buy fresh fruit to enjoy while painting *en plein air*. Early in his painting career broccoli was practically unheard of in Normandy, and after he tested it at Giverny it became one of his favorite vegetables. Here we add the broccoli, which Monet grew in his kitchen garden, to the classic preparation of pasta with brown butter enhanced with sage, an herb that Monet also grew. This lusty dish is perfect on its own for a lunch or late supper, or as an accompaniment to any roasted or grilled meat, fish or fowl. Pour a Verdicchio or Dolcetto d'Alba.

Bring a large pot of salted water to boil. Add broccoli and boil until just tender but still firm to bite, 3 to 4 minutes. Using a slotted spoon, transfer broccoli from pot to colander. Drain under cold water to stop cooking and preserve color. Toss broccoli with lemon juice. Return large pot of salted water to boil. Add pasta and boil until tender but still firm to bite, stirring occasionally, about 10 minutes.

Meanwhile, melt butter in a large heavy skillet over medium heat. Add sage leaves and cook until butter is nutty brown in color and sage leaves are crisp, 3 to 4 minutes. Remove from heat.

Drain pasta, reserving 1/2 cup (120 ml) cooking water. Add pasta, cooked broccoli and 1/4 cup (25 g) Parmesan cheese to butter in skillet and toss to coat. Return skillet to low heat and toss 1 minute to heat pasta through, adding reserved pasta water a little at a time if dish is dry. Season with salt and pepper to taste. Divide pasta among bowls. Garnish with parsley. Serve immediately, passing additional Parmesan cheese and red pepper flakes separately.

Venetian-Style Spaghetti with Roasted Tomatoes, Anchovies and Capers

4 MAIN COURSE SERVINGS

8 plum tomatoes, halved

¼ cup (60 ml) extra virgin olive oil

2 teaspoons minced garlic

¼ teaspoon dried oregano, crumbled

Salt and freshly ground pepper

8 anchovies from tin or jar, drained and halved

1 tablespoon capers, rinsed and drained

1 tablespoon balsamic vinegar

1 pound (450 g) whole-wheat or regular spaghetti

¼ teaspoon red pepper flakes

2 tablespoons (¼ stick) (30 g) unsalted butter, room temperature

6 whole fresh basil leaves

Salt and freshly ground pepper

Monet visited Venice twice in his lifetime. While there, he not only painted its magnificent architecture in the volcanic colors of a sunset or the muted pastel colors of a morning mist, but he also sought out the restaurants that served the best of Italian cuisine. He might have enjoyed a dish such as this, as he loved robust, flavorful food. While whole-wheat spaghetti, known as *bigoli*, is typical of Venice, feel free to use any long white pasta, such as linguine, fettuccine, *bucatini* or *perciatelli*. A wine from the Veneto region would be appropriate. If you prefer white try Soave, and if you prefer red try Valpolicella.

Preheat oven to 275 F (135 C). Toss tomato halves, olive oil and garlic in a medium-size bowl Arrange tomato halves cut side up on a baking sheet. Sprinkle with oregano. Season with salt and pepper. Roast until tomatoes are soft and beginning to brown, about 1 hour. Remove tomatoes from oven and place 1 anchovy half over each tomato half. Sprinkle with capers. Drizzle with balsamic vinegar. Continue roasting until anchovies begin to soften, about 5 minutes.

Meanwhile, bring a large pot of salted water to boil. Add spaghetti and boil until tender but still firm to bite, stirring frequently to prevent sticking, 10 to 12 minutes. Drain spaghetti and return to pot. Add roasted tomatoes with all juices and stir well over low heat. Stir in pepper flakes. Add butter and basil and stir until butter has melted. Adjust seasoning with salt and pepper. Serve immediately.

Garden-Inspired Side Dishes

Red Cabbage, Fennel, Carrot and Fennel Seed Slaw

3 tablespoons (45 ml)
extra virgin olive oil

1 tablespoon (15 ml) orange juice

1 teaspoon (7 g) honey

1 teaspoon Dijon mustard

1/2 teaspoon salt

1/4 teaspoon freshly ground pepper

1/8 teaspoon crushed fennel seeds

1 large fennel bulb, trimmed
(fronds reserved) and thinly sliced

1 large carrot, peeled
and finely shredded

1 small red onion, thinly sliced

1/2 cup (50 g) shredded red cabbage

Monet had a passion for red cabbage, which he grew in cold frames to ensure an early harvest. While he would have most often eaten *choux rouge* by itself, either braised or pickled, this light slaw is filled with several of his favorite vegetables for a colorful presentation. This is a perfect accompaniment to roasted or fried chicken, ribs or any sandwich. Why not pop open a beer?

Place oil, juice, honey, mustard, salt, pepper and fennel seeds in a large bowl. Add fennel (not fronds), carrot, onion and cabbage. Toss well. Cover and refrigerate 1 hour.

Mince fennel fronds so you have 1 tablespoon. Transfer slaw to platter. Garnish with minced fennel fronds. Serve cold or room temperature.

Chilled Asparagus Salad with Olives, Capers and Orange

4 TO 6 SIDE DISH SERVINGS

¹⁄₄ cup (60 ml) extra virgin olive oil

2 tablespoons (30 ml) orange juice

2 teaspoons freshly grated orange peel, divided

¹⁄₄ teaspoon salt

¹⁄₄ teaspoon freshly ground pepper

¹⁄₈ teaspoon red pepper flakes

1 cup (100 g) chopped pitted niçoise or kalamata olives

1 tablespoon capers, drained, rinsed and chopped

1 large garlic clove, minced

2 pounds (900 g) asparagus, ends trimmed

Asparagus is an early crop that was held in high regard by Monet, and he made sure that his cook, Marguerite, prepared it two ways. For Monet himself, who believed overcooking was sacrilegious, the asparagus was lightly steamed to make it tender, but not enough to lose its crisp, nutty flavor. For his family, who preferred their asparagus well cooked, Marguerite would prepare a separate batch. Here the spears are dressed with an olive, caper and orange relish that Monet surely would have liked, as it is similar to the *tapenade* that he enjoyed on his painting trips along the French Riviera. While we call for the asparagus to be chilled, you can also serve it warm or at room temperature. This dish is ideal for a light lunch—make sure to prepare extra relish to serve on the side with crusty bread—or an apt prelude to grilled lamb, chicken or fish. Pour a well-chilled rosé.

Place oil, juice, 1 teaspoon orange peel, salt, pepper and red pepper flakes in a medium-size bowl. Whisk well to blend. Add olives, capers and garlic and mix well. Cover and let stand at room temperature 1 hour. Adjust seasoning with salt and pepper if necessary.

Meanwhile, steam or boil asparagus until tender but still firm to bite; time will vary depending on size of asparagus. Drain well and rinse under cold water to stop cooking process and set color. Transfer asparagus to a platter and pat dry. Cover and refrigerate until cold.

Spoon olive mixture over asparagus. Garnish with remaining 1 teaspoon orange peel. Serve immediately.

Baked Sweet Potato Fries with Horseradish Sauce

8 APPETIZER OR SIDE DISH SERVINGS

3 pounds (1,350 kg) dark orange-fleshed sweet potatoes or yams

¼ cup (60 ml) extra virgin olive oil

Salt

½ cup (120 g) light mayonnaise

½ cup (120 g) sour cream

¼ cup (60 g) prepared horseradish, drained

1 tablespoon snipped fresh chives

1½ teaspoons fresh lemon juice

Sea salt

Freshly ground pepper

Coarse salt

It might come as a surprise to hear that Monet was a fan of horseradish-based sauces with roasted meats; his dear cook, Marguerite, obliged by adding them to her repertoire. We, too, love the tang of the pungent, sinus-clearing root, especially when stirred into a creamy base, as we have done here. While this sauce is amazing with crispy baked sweet potato fries, it is also delicious with poached chicken or fish. Or try it with roast beef, as Monet might have done. When choosing sweet potatoes, look for ones that are as straight as possible; it makes for easier slicing.

Wash potatoes well but do not peel. Cut into matchstick slices. Place in a large bowl. Cover with cold water. Let stand 30 minutes.

Preheat oven to 375 F (190 C). Drain potatoes and pat dry. Place in a clean, dry large bowl. Add olive oil, sprinkle with salt and toss well. Transfer potatoes to nonstick baking sheets and arrange in single layer. Bake until potatoes are crisp and browned around edges, about 25 minutes, rotating sheets halfway through.

Meanwhile, place mayonnaise, sour cream, horseradish, chives and lemon juice in a small bowl and whisk to blend well. Season sauce with salt and pepper to taste.

Transfer potatoes to serving platter. Season with pepper and coarse salt. Transfer sauce to serving bowl. Serve immediately.

Zucchini "Pasta" with Sautéed Mushrooms and Brown Butter

6 SIDE DISH OR 4 MAIN COURSE SERVINGS

3 medium-size zucchini

2 tablespoons (30 ml) extra virgin olive oil

1 large garlic clove, minced

1/2 cup (60 g) chanterelle mushrooms, quartered

1/2 cup (60 g) cremini mushrooms, quartered

1/4 teaspoon dried oregano, crumbled

1/8 teaspoon red pepper flakes

1/4 cup (40 g) quartered cherry tomatoes

Salt and freshly ground pepper

1/4 cup (1/2 stick) (60 g) unsalted butter

2 tablespoons freshly grated Pecorino Romano cheese

1 tablespoon chopped fresh parsley

1 tablespoon chopped fresh basil

Claude Monet so much enjoyed zucchini during his painting excursions to Italy that he introduced it to Normandy by way of his kitchen garden. He brought seeds back from his trips to Provence and Italy and planted them in his garden. The variety he cultivated, Ronde de Nice, is actually a bright-green round with white stripes and is just one of the many kinds grown today. Here we call for the more standard long zucchini in order to obtain strips for our faux pasta dish. We call for chanterelle as well as cremini mushrooms; if chanterelles are unavailable, just use all cremini. This makes for a lovely accompaniment to grilled lamb or fish, and is equally as good as a vegetarian main course. Pour any chilled dry white wine or rosé.

Using a vegetable peeler, peel entire length of each zucchini to create strips. Continue peeling down to seed core; discard seed core. Heat olive oil in a large heavy skillet over medium-low heat. Add garlic and stir 1 minute. Add zucchini, mushrooms, oregano and pepper flakes and sauté 5 minutes. Stir in tomatoes. Season with salt and pepper. Keep mixture warm over very low heat.

Melt butter in a small heavy saucepan over medium-low heat and swirl until butter is light brown and has nutty aroma. Pour over zucchini mixture. Transfer to a serving platter. Sprinkle with cheese, parsley and basil. Serve immediately.

Cucumber, Corn, Red Pepper and Fennel Salad with Fennel Frond Dressing

6 SIDE DISH SERVINGS

3 medium-size cucumbers, peeled and halved lengthwise

3/4 cup (130 g) fresh or frozen corn kernels

3/4 cup (130 g) diced red pepper

3/4 cup (75 g) thinly sliced fennel

6 tablespoons (60 g) chopped red onion

1/4 cup (60 ml) extra virgin olive oil, plus more if desired

1 1/2 tablespoons fresh lemon juice, plus more if desired

Salt and freshly ground pepper

1/4 cup (5 g) coarsely chopped fennel fronds

Monet was so fortunate. The luminous light of Normandy inspired his impressionist style of painting, and the long summer daylight hours inspired a multitude of vegetables and fruits to grow in his garden. Everything in this simple, refreshing salad could be pulled from his kitchen garden. When you slice the fennel bulb, make sure to save the feathery fronds for the garnish. This is delicious alongside grilled chicken or fish; sliced cold roast beef, pork or lamb; or even hamburgers. If you want to turn this into a main-course salad, add chopped cheese and/or sliced egg and serve it on a bed of frisée lettuce. Pour a chilled pinot gris or rosé.

Using a small spoon, remove seeds from cucumbers. Dice cucumbers. Combine cucumbers, corn, red pepper, sliced fennel and onion in a large bowl. Add 1/4 cup (60 ml) oil and 1 1/2 tablespoons lemon juice and toss well. Add additional oil and lemon juice if desired. Season to taste with salt and pepper. Cover and refrigerate 30 minutes.

Let salad stand at room temperature 5 minutes. Transfer to a serving platter. Garnish with fennel fronds. Serve immediately.

Roasted Confetti Vegetables

6 SIDE DISH SERVINGS

3 cups (450 g) peeled
and diced carrots

3 cups (450 g) peeled
and diced turnips

2 cups (300 g) peeled
and diced beets

1 large leek, halved and
thinly sliced, white and
light-green parts only

3 garlic cloves, thinly sliced

1/4–1/2 cup (60–120 ml)
extra virgin olive oil

Salt and freshly ground pepper

1–2 large fresh rosemary sprigs

1 1/2 tablespoons chopped
fresh flat-leaf parsley

The colors, tastes and textures of this hearty side dish use a collection of root vegetables that Monet grew and would have stored to enjoy during the winter months. A favorite heirloom turnip is the Purple Top White Globe. The simplicity of this preparation brings out the earthy sweetness of this favorite French veggie. Keep in mind that the smaller the turnips, the more sweet and tender they will be. Serve this alongside any roasted or baked meat, fish or fowl. Or, for a luscious vegetarian option, serve atop brown rice and crown with a fried egg. Pour a light red, such as Beaujolais.

Preheat oven to 375 F (190 C). Combine carrots, turnips, beets, leek and garlic in single layer in a large roasting pan or on a large baking sheet. (Use two pans or sheets if necessary so vegetables are in single layer.) Drizzle each pan or sheet with 1/4 cup (60 ml) olive oil and season with salt and pepper. Toss well to combine. Top each pan or sheet with rosemary sprig. Cover with foil and roast until vegetables are fork tender, about 30 minutes. Uncover and continue roasting until vegetables are lightly browned and caramelized. Discard rosemary. Transfer to serving platter. Sprinkle with parsley.

French Green Beans with Walnut, Parsley and Orange Relish

6 SIDE DISH SERVINGS

½ cup (60 g) chopped walnuts

½ cup (15 g) chopped fresh parsley

½ cup (120 ml) fresh orange juice

2 teaspoons freshly grated orange peel

1 teaspoon salt

½ teaspoon freshly ground pepper

½ cup (120 ml) extra virgin olive oil

2 pounds (900 g) thin French green beans (haricots verts), ends trimmed

The thin French green beans known as *haricots verts* were a favorite of Monet's; luckily they grew well in his kitchen garden. While Monet adored the cooking of his chef, Marguerite, he preferred the way her husband, Paul, made the pencil-thin verdant vegetable crispy but tender by not overcooking. Haricots verts are readily available in fine supermarkets and farmers' markets, but if you cannot find them, try any green bean you like. The relish sings with other prominent French flavors and brings new life to an old standby. Serve alongside any simple meat, fish or fowl preparation, or serve the dish as a light lunch, accompanied by crusty bread and cheese. Pour a bright white such as Pinot Blanc.

Combine walnuts, parsley, orange juice and peel, salt and pepper in a medium-size bowl. Stir in olive oil. Set aside until ready to use. *(Can be prepared several hours ahead. Cover and store at room temperature.)*

Bring large pot of salted water to boil. Add green beans and cook until tender but still firm to bite, about 5 minutes. Drain well. Transfer beans to a serving platter. Dress with relish. Serve immediately or at room temperature.

Cremini Mushroom, Shallot and Herb Sauté

6 SIDE DISH SERVINGS

2 tablespoons (30 ml)
extra virgin olive oil

1 1/2 pounds (675 g) cremini
mushrooms, thickly sliced

2 tablespoons (20 g) minced shallot

1 teaspoon minced garlic

1 tablespoon minced fresh thyme

1 large fresh rosemary sprig

1/2 teaspoon salt

1/2 teaspoon freshly ground pepper

1/4 cup (1/2 stick) (60 g)
unsalted butter

1 tablespoon minced
fresh flat-leaf parsley

Monet loved mushrooms so much that he grew them in the cave-like basement of the Blue House, adjacent to his kitchen garden. At the time, it was not known how to cultivate any other mushroom than the so-called white button mushroom and its brown-skinned version called cremini. But the real prizes were the wild mushrooms that his sons picked in the local woods after a rain. Monet loved them prepared merely sautéed in olive oil and swirled with butter as we do in this recipe. We specify cremini mushrooms, as they are readily available and affordable, but if you can find them use morels or black trumpets for their haunting flavor. Serve alongside roasted chicken, pork or veal or even a cheese omelet. Pour a red wine such as Brouilly, Fleurie or Morgon.

Heat olive oil in a large heavy skillet over medium-high heat. Add mushrooms, shallot, garlic, thyme, rosemary, salt and pepper and sauté until mushrooms are cooked and caramelized, about 10 minutes. Add butter and swirl until butter coats all mushrooms. Discard rosemary sprig. Transfer mushrooms to a serving bowl. Garnish with parsley. Serve immediately.

A BELLE ÉPOQUE PICNIC IN GIVERNY

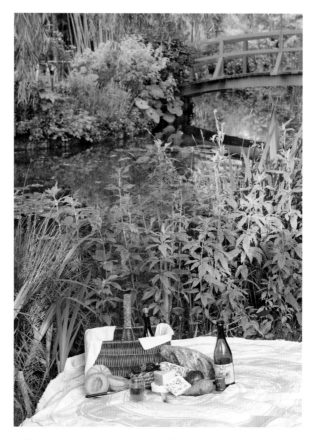

Picnics were a favorite pastime enjoyed by Claude Monet and his family and friends. Imagine a sunny spring day with the perfume of Monet's garden in the air. A luxurious French blanket or his rattan table with chairs is placed near his green bridge. A typical picnic menu in France during the era of La Belle Époque would always include champagne and wine. Monet's picnics and luncheons often included a pitcher of sparkling apple cider. A typical menu at a French picnic might include salmon paté, brioche and baguette breads with Normandy's famed Isigny butter. There would always be a diverse cheese platter of Camembert, Pont l'Evêque and Livarot, goat, and Roquefort cheeses. Picnic favorites like roasted quail, hard-boiled quail eggs, finger sandwiches and sponge cakes were easy to consume en plein air. Of course, a colorful salad composed of vegetables picked that morning was obligatory. The salad would include 'Scarlet Nantes' carrots, petite pois green peas, cherry tomatoes, 'French Breakfast' red-and-white radishes, 'Golden Bantam' sweet corn, fennel, chives, 'Merveille de Quatre Saisons' lettuce, all dressed with a Dijon mustard vinaigrette. Monet's Palate is visually highlighted in the famed painting *Déjeuner sur L'Herbe* ("Luncheon on the Grass"), which includes a true *pique-nique* feast shown on facing page.

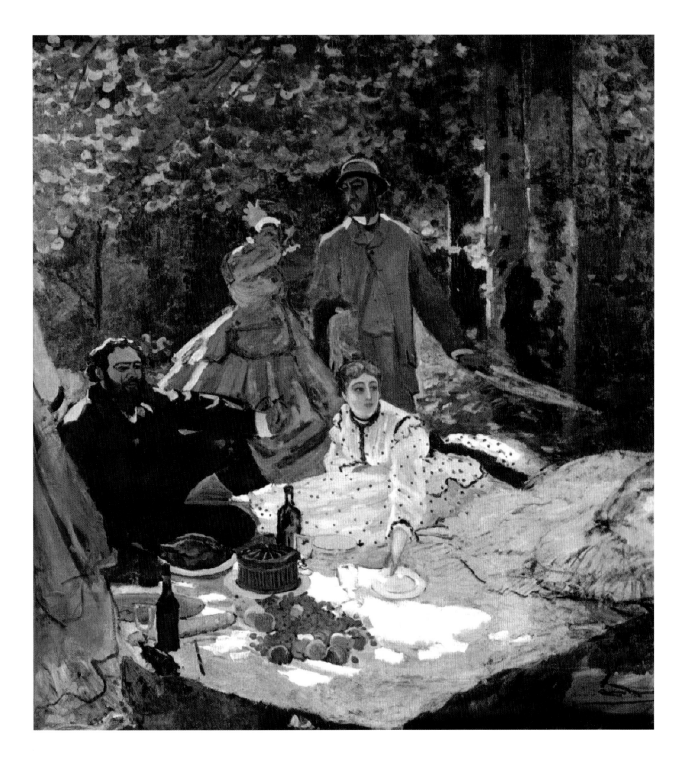

Desserts

Rosemary Butter Sandwich Cookies with Fig Jam 144

Normandy French Apple Tart 147

Fresh Fruit Salad with Honey Crème
Fraîche and Mint 148

Baked Pears with Brown Sugar,
Almonds and Marzipan 150

Baked Apples with Sugar-and-Spice Fig,
Walnut and Orange Butter 151

Banana Ice Cream with Candied Orange Peel,
Spiced Hazelnuts and Chocolate Sauce 152

Peach, Apple and Raisin Gratin
with Walnut Streusel 155

Mocha Layer Cake 156

Rosemary Butter Sandwich Cookies with Fig Jam

MAKES 2 DOZEN COOKIES

1 cup (2 sticks) (230 g) salted butter, cut into pieces, room temperature

1 cup (200 g) sugar

2 teaspoons vanilla extract

1 teaspoon dried rosemary, crumbled

1/2 teaspoon almond extract

2 1/4 cups (270 g) all-purpose flour

1 cup (325 g) fig jam or preserves

Powdered sugar

Normandy is renowned for everything dairy and, above all, for its butter. In the film *Monet's Palate* you can hear the joy in culinary legend Alice Waters' voice when she talks about that butter, stating, "they have butter, really good butter!" That butter went into the many and varied cookies that Monet's cook, Marguerite, made to satisfy Monet's sweet tooth in general and love for cookies in particular. Here we take a classic butter cookie—a Norman specialty—and introduce the savory and piney note of rosemary. It is the perfect complement to rich fig jam. Monet espaliered figs up the stone wall of his kitchen garden. No doubt Florimond, the gardener, would have picked the fruit at the peak of ripeness from a first crop in spring and a second crop in fall, and Marguerite would have turned it into jam. Serve these luscious treats with coffee, tea or a glass of milk as a late-afternoon or before-bedtime snack.

Place butter, sugar, vanilla, rosemary and almond extract in a food processor. Process until just smooth. Add 1 cup (120 g) flour and pulse until mixture just comes together. Add remaining flour and pulse until stiff ball forms; mixture will be dry. Divide dough in half. Shape each into an 8-inch (20 cm) log. Wrap each in waxed paper. Refrigerate until firm, about 2 hours.

Preheat oven to 350 F (180 C). Cut each dough log into 1/3-inch-thick (0,8 cm) slices. Place slices 1 inch (2,5 cm) apart on nonstick baking sheets. Bake until cookies are cooked through but not browned, 8 to 9 minutes. Using spatula, transfer cookies to wire rack and cool completely.

To assemble, spread flat sides of half of cookies with 2 teaspoons fig jam each. Top with remaining half of cookies to form sandwiches. Arrange cookies on a platter. Dust with powdered sugar. *(Can be prepared 1 day ahead and stored in airtight container at room temperature.)*

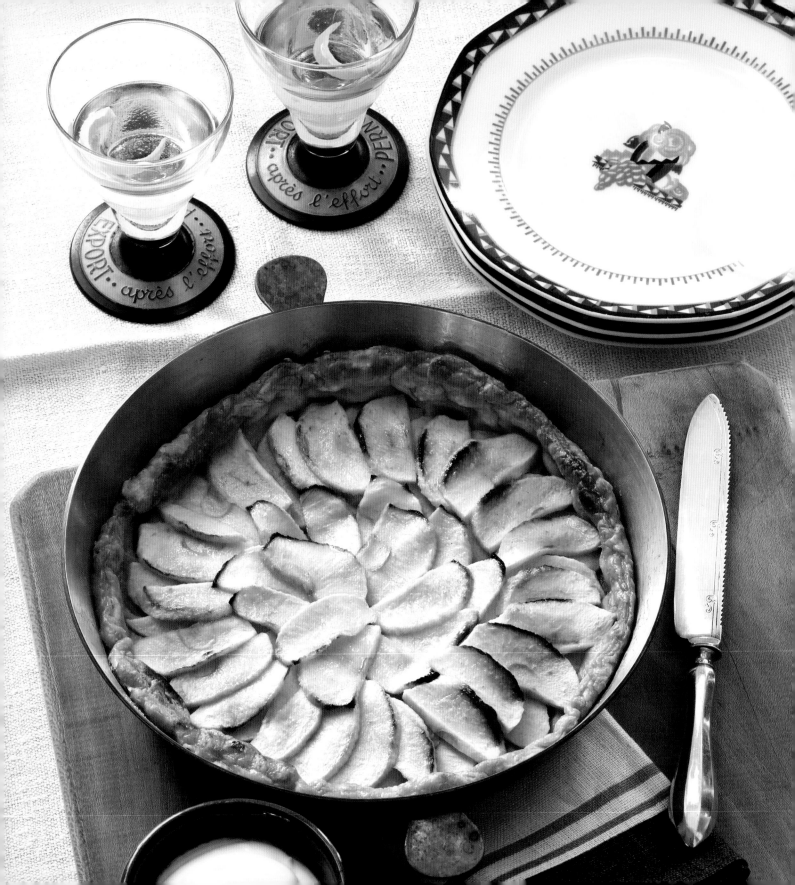

Normandy French Apple Tart

4 DESSERT SERVINGS

4 squares or sheets
prepared puff pastry

4 large golden delicious apples,
peeled, cored and thinly sliced

Calvados or applejack

6 tablespoons (40 g)
powdered sugar

Crème fraîche

Given the proliferation of apples in Normandy, it is not surprising that some variation of an apple tart is the signature dessert of the region. And, *bien sûr*, it was also a favorite of Monet and his family. He and his wife, Alice, brought back the recipe for Tarte Tatin, the renowned upside-down caramelized apple tart, from their stays at Hôtel Tatin in Lamotte-Beuvron, about 100 miles south of Paris. Monet painted a seductive version of an apple tart in a famous canvas titled *Les Galettes* (*The Cakes*). In the film *Monet's Palate*, Chef Maurice Amiot prepares the following simple yet sophisticated recipe. He recommends serving these individual tarts with crème fraîche, but vanilla ice cream or whipped cream would also be superb!

Preheat oven to 400 F (200 C). Cut each square puff pastry into an 8- to 9-inch (20 cm to 23 cm) circle and set on nonstick baking sheet; discard scraps or reserve for another use. Sprinkle apple slices with a little Calvados and toss to coat. Arrange apple slices on each pastry circle in concentric circles from outside edge of pastry to center. Bake 10 minutes. Dust each tart with 1 1/2 tablespoons powdered sugar and continue baking until apples are tender and gently browned, 10 to 15 minutes. Increase heat to broil and broil until apples are caramelized, 2 to 3 minutes; do not burn. Drizzle each tart with a little Calvados. Serve immediately with dollop of crème fraîche.

Fresh Fruit Salad with Honey Crème Fraîche and Mint

1 cup (240 g) crème fraîche

2 tablespoons (40 g) honey

1/4 teaspoon vanilla extract

4 peaches, pitted and sliced

1 1/2 cups (200 g) raspberries

1 cup (100 g) blueberries

1 cup (125 g) blackberries

1/2 cup (15 g) chopped mint leaves

Monet grew peaches against the walls of his kitchen garden to save valuable space. They are featured in a lovely canvas titled *Jar of Peaches* (although they appear to be apricots), in which the summer fruit has been preserved in brandy. In a canvas titled *Peaches and Grapes with Melon*, the peaches are a special French maroon-skinned variety known as the vineyard peach, which is sweet and juicy. Moreover, they would have been an essential part of any family picnic, probably drizzled with a fruity blood-orange liqueur made from Sicilian blood oranges, or Monet's own rhubarb wine. Here we take advantage of ripe seasonal fruit and toss it with beautiful berries, and serve with a dollop of crème fraîche—infused with honey. This light dessert is perfect after a heavy meal, or offered for breakfast or brunch.

Whisk together crème fraîche, honey and vanilla in a small bowl. Place peaches and all berries in a large bowl and toss well. Transfer fruit to a serving platter. Drizzle with crème fraîche mixture and garnish with mint. Serve immediately.

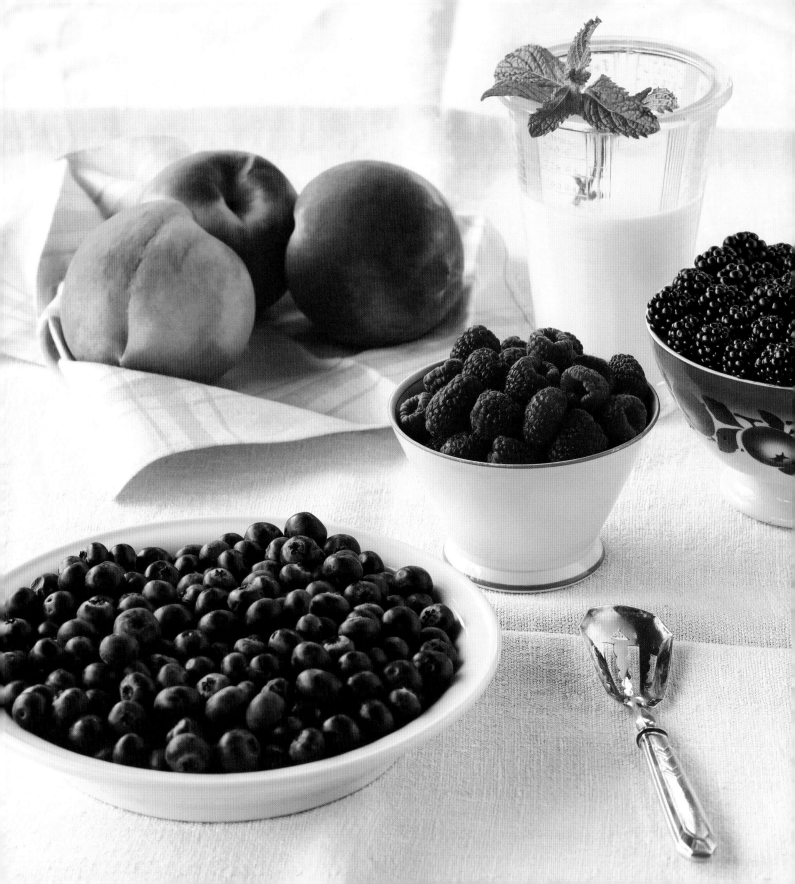

Baked Pears with Brown Sugar, Almonds and Marzipan

6 DESSERT SERVINGS

6 medium-ripe Bartlett or Bosc pears, stems removed, cored

3 tablespoons (15 g) sliced almonds, toasted, divided

2 tablespoons (25 g) firmly packed dark brown sugar

2 ounces (60 g) marzipan

½ cup (120 ml) apple juice

½ cup (120 ml) water

2 tablespoons (¼ stick) (30 g) salted butter, cut into small pieces

1 tablespoon chopped fresh mint

Monet was so fond of pears that he grew them espaliered up the walls of his flower and vegetable gardens. His painting *Still Life with Pears and Grapes* showcased the fruit that he loved almost as much as apples. A brandy that is the pear equivalent of Calvados is also made in Normandy; serve it with this simple yet extremely satisfying dessert.

Preheat oven to 400 F (200 C). Stand pears up in an ovenproof dish. Place 2 tablespoons almonds, sugar and marzipan in small bowl. Using fork, mix until crumbly. Spoon mixture into pears, dividing evenly. Pour apple juice and water around pears. Sprinkle pears with remaining 1 tablespoon almonds. Dot with butter. Cover with foil and bake until pears are fork tender, about 30 minutes (time will vary depending on ripeness of pears). Place each pear in a small bowl. Drizzle cooking juices over the pears. Garnish with mint.

Baked Apples with Sugar-and-Spice Fig, Walnut and Orange Butter

¹/₂ cup (1 stick) (120 g) unsalted butter, room temperature

¹/₂ cup (90 g) firmly packed dark brown sugar

2 tablespoons (40 g) fig preserves or jam

1 teaspoon freshly grated orange peel

¹/₂ teaspoon ground cinnamon

¹/₄ teaspoon salt

4 tablespoons (30 g) crushed walnuts, divided

8 large apples, cored, bottoms trimmed flat

Boiling water

Monet grew an assortment of French heirloom apple trees which to this day line the main gate. This preparation of baked apples is elevated with a decadent compound butter. Use whatever locally grown apple you can obtain, such as an heirloom King of the Pippins or a tart-sweet heirloom baking apple such as a Granny Smith. Traditional baking apples such as a Rome Beauty or Golden Delicious are very good choices. Pour a tawny Port.

Line baking sheet with parchment or waxed paper. Place softened butter in a medium-size bowl. Add sugar, preserves, orange peel, cinnamon and salt. Fold in 2 tablespoons walnuts. Line a small baking sheet with waxed or parchment paper. Shape butter into cylinder or log and set in center of one short end of paper. Roll up paper as for a jelly roll until butter is entirely enclosed in paper. Using kitchen string or twine, tie paper on both ends. Refrigerate at least 8 hours or overnight. *(Can be prepared 1 week ahead and refrigerated or frozen. If frozen, defrost before using.)*

Preheat oven to 375 F (190 C). Arrange apples in a large glass baking dish. Pour boiling water around apples to reach 1 inch (2,5 cm) up sides of apples. Cover with foil. Bake until apples are soft, about 1 hour.

Remove butter from paper. Cut butter into 8 medallions. Set 1 hot apple on each plate. Top each with butter medallion. Garnish with remaining 2 tablespoons crushed walnuts. Serve immediately.

Banana Ice Cream with Candied Orange Peel, Spiced Hazelnuts and Chocolate Sauce

6 DESSERT SERVINGS

ICE CREAM

2 cups (480 g) heavy cream

1 cup (240 ml) whole milk

3 large ripe bananas, peeled and mashed

6 large egg yolks

1/2 cup (100 g) sugar

6 tablespoons (70 g) firmly packed dark brown sugar

Monet was familiar with bananas from his travels to the French and Italian Rivieras as well as to North Africa. While clearly he could not grow the tropical fruit in Normandy's cool climate, he did import them for his traditional Christmas dessert: banana ice cream. While the story of how this surprising sweet came to be the finale for this important holiday meal has been lost to time, the flavors have been captured perfectly in this recipe. We dress things up with orange, hazelnuts and chocolate. What could be better?

FOR ICE CREAM: Place cream and milk in a large heavy saucepan over medium heat. Add bananas and stir to incorporate bananas into liquid. Meanwhile, place yolks and sugar in a large heavy glass mixing bowl. Whisk until sugar is well dissolved into eggs. Using a ladle, add a little banana mixture to egg mixture and whisk well. Pour entire mixture back into saucepan. Set over low heat and cook until mixture is thick enough to coat the back of a spoon, stirring constantly, about 5 minutes. Pour mixture into a clean bowl. Cover and refrigerate until custard is chilled. Transfer mixture to ice cream maker and churn, following manufacturer's instructions. Transfer ice cream to an airtight container and freeze. *(Can be prepared 1 day ahead.)*

(continued)

CANDIED ORANGE PEEL

1 pound (450 g) oranges, washed

Water

1 cup (200 g) sugar

1 tablespoon light corn syrup

HAZELNUTS

1/4 cup (45 g) firmly packed dark brown sugar

1 tablespoon (15 g) unsalted butter, melted

1/2 teaspoon salt

Pinch of cayenne pepper

1 cup (150 g) hazelnuts, toasted, skins removed

12 tablespoons (180 ml) prepared chocolate sauce

FOR PEEL: Peel oranges, removing orange part of peel only. Reserve fruit for another use. Cut peel into 3/8-inch-thick (1 cm) slices. Place sliced peel in a medium-size heavy saucepan. Add enough water to cover, bring to boil and blanch 2 to 3 minutes to remove bitterness. Drain peel and pat dry. Place 3/4 cup (180 ml) water, sugar and corn syrup in same medium-size heavy saucepan and stir to dissolve sugar. Add orange peel and bring to boil. Reduce heat and simmer until liquid has reduced by half and peel is candied, 30 to 45 minutes; DO NOT STIR, OR CRYSTALS WILL FORM. Transfer peel to cooling rack and let sit until firm. *(Can be prepared 1 day ahead. Store in airtight container.)*

FOR HAZELNUTS: Preheat oven to 350 F (180 C). Combine sugar, butter, salt and pepper in a small bowl. Add hazelnuts and toss to coat. Transfer hazelnuts to a large nonstick baking sheet. Bake until nuts are golden brown, 5 to 10 minutes. Transfer to plate and cool completely. *(Can be prepared 1 day ahead. Store in airtight container.)*

TO SERVE: Place 2 scoops ice cream in each of 6 bowls. Drizzle each with 2 tablespoons chocolate sauce. Top each with 1/6 of hazelnuts and 1/6 of orange peel. Serve immediately. (Alternatively, ice cream can be layered with sauce, nuts and peel for sundae.)

Peach, Apple and Raisin Gratin with Walnut Streusel

6 DESSERT SERVINGS

STREUSEL

2/3 cup (80 g) all-purpose flour

3 tablespoons (35 g) firmly packed dark brown sugar

2 tablespoons (25 g) sugar

1 teaspoon ground cinnamon

1/8 teaspoon finely chopped fresh rosemary

1/8 teaspoon salt

1/2 cup (60 g) chopped walnuts

1/2 cup (1 stick) (120 g) unsalted butter, melted

1/8 teaspoon vanilla

GRATIN

2 cups (450 g) thinly sliced peeled peaches

1 cup (175 g) thinly sliced tart apple

1/2 cup (100 g) sugar

1/4 cup (40 g) raisins

1 teaspoon fresh lemon juice

Monet grew his own peaches, espaliered against a walled enclosure that surrounded his vegetable garden. But it wasn't enough for Monet to grow the fruit; a white-flesh peach called *pêche de la vigne* also appeared in one of his paintings. A similar peach called Spring Snow is available in the United States. Here the beautiful fruit is combined with apples and raisins and topped with a walnut streusel kissed with rosemary in a gratin that is sure to please. Serve with vanilla ice cream, whipped cream or crème fraîche.

FOR STREUSEL: Place flour, both sugars, cinnamon, rosemary and salt in a medium-size bowl. Using a fork, stir to combine. Stir in walnuts. Add melted butter and vanilla and stir to combine. Set aside until ready to use.

FOR GRATIN: Preheat oven to 400 F (200 C). Butter a 9-inch (23 cm) glass pie dish. Combine peaches, apple, sugar, raisins and lemon juice in a medium-size bowl. Transfer to prepared dish. Bake until fruit is tender, about 35 minutes. Spread streusel evenly over fruit. Return to oven and bake until golden brown, about 10 minutes. Let cool to room temperature and serve.

Mocha Layer Cake

CAKE

Parchment paper and
nonstick spray for pans

2 cups (240 g) all-purpose flour

1/2 cup (50 g) unsweetened
cocoa powder

2 tablespoons instant coffee
powder (not crystals)

2 teaspoons baking powder

1/2 teaspoon salt

1/2 cup (1 stick) (120 g) salted
butter, room temperature

1 teaspoon freshly
grated orange peel

1 teaspoon vanilla extract

1/2 cup (90 g) firmly packed
dark brown sugar

1/2 cup (100 g) sugar, divided

3/4 cup (180 ml) whole milk,
room temperature

4 large egg whites,
room temperature

Monet often felt the need to leave home for a spell, both to get a respite from his demanding domestic and professional life as well as to meet friends in a quiet and less personal environment. During the summer months Renoir and Cezanne rented houses in La Roche Guyon, a village not far from Giverny. When they did so, as well as at other times, Monet liked to stay at the Hôtel d'Evreux, located in the center of Vernon, the nearest town. The timbered structure with its large paneled dining room, decorated with boars' and stags' heads, was the ideal place for a meal, either alone or with his artist friends. Monet loved the hotel's mocha cake, for which it was famous. While the hotel is currently closed, the recipe for the cake–or an approximation thereof—remains. This cake, in typical European style, is lighter and drier than its American counterpart and is filled but not frosted. It is perfect for dessert or a late-afternoon treat. Don't forget the coffee or tea!

FOR CAKE: Position rack in bottom third of oven and preheat to 350 F (180 C). Line the bottoms of two 9-inch (23 cm) round cake pans with parchment paper; lightly coat paper and pan sides with spray. Sift flour, cocoa powder, coffee powder, baking powder and salt into a medium-size bowl. Place butter, orange peel and vanilla in a large bowl. Using an electric mixer, beat until blended. Gradually add brown sugar and 1/4 cup (50 g) granulated sugar and beat until smooth and fluffy. At low speed, beat in dry ingredients in 3 additions alternating with milk in 2 additions, beating about 5 to 10 seconds each time; do not overbeat. Place egg whites in clean, dry medium-size bowl. Using clean, dry beaters, beat whites at medium-high speed until soft peaks form. Add remaining 1/4 cup (50 g) granulated sugar and beat until stiff but

FILLING

1/2 cup (1 stick) (120 g) salted butter, room temperature

1 tablespoon unsweetened cocoa powder

1 1/2 teaspoons instant coffee powder (not crystals)

10 ounces (2 1/2 cups) (280 g) powdered sugar

2 tablespoons (30 ml) whole milk, room temperature

WHIPPED CREAM

1 cup (240 g) chilled heavy cream

2 tablespoons (25 g) sugar

1 teaspoon instant coffee powder (not crystals)

1 teaspoon unsweetened cocoa powder

2 tablespoons (15 g) powdered sugar

not dry peaks form. Fold whites into batter in 3 additions. Divide batter equally between prepared pans. Bake cakes 15 minutes. Reverse pan positions and continue baking until tester inserted in center comes out clean, 8 to 10 minutes longer. Cool cakes in pans 5 minutes. Turn cakes out onto rack; peel off parchment paper. Turn cakes right side up and cool completely.

FOR FILLING: Place butter, cocoa powder and coffee powder in a large bowl. Using an electric mixer, beat until blended and fluffy. Beat in powdered sugar 1/2 cupful (50 g) at a time. Add milk and beat until smooth. If necessary, chill until firm spreading consistency, about 30 minutes, stirring occasionally.

FOR WHIPPED CREAM: Place all ingredients in a medium-size bowl. Using an electric mixer, beat until soft peaks form. Chill until ready to serve.

TO ASSEMBLE: Place 1 cake layer on a platter. Spread filling over top; do not frost sides. Place another cake layer atop filling; press to adhere. Sift powdered sugar thickly over cake.

TO SERVE: Cut cake into slices. Spoon whipped cream alongside.

Craft Cocktails & Spirits

The Poppy

MAKES 1 COCKTAIL

3 strawberries

1 ounce (2 tablespoons)
(30 ml) Cointreau or other
orange-flavored liqueur

1/2 ounce (1 tablespoon) (15
ml) fresh lemon juice

Ice cubes

1 1/2 ounces (3 tablespoons)
(45 ml) vodka

1/4 ounce (1 1/2 teaspoons)
(7 ml) orange juice

1 orange peel twist

The poppy was a recurring and enduring theme in Monet's home and garden, and he paid homage to the flower in *The Poppy Field*, one of his best-known landscape paintings. The strawberries in this refreshing cocktail mimic the color of the poppy, hence the name of the libation. Although small strawberries grew wild around Giverny and were gathered by Monet's sons, he had a bed of larger cultivated strawberries that he insisted be picked at their best. When in season, they were harvested by the basketful, dipped quickly into a bowl of water to remove any dirt, and enjoyed *au natural*. The combination of orange and strawberry are perfectly suited for this spring or summer cocktail.

Place strawberries in the bottom of a cocktail shaker. Add Cointreau and lemon juice. Using the back of a spoon, muddle strawberries into liquid. Fill shaker with ice cubes. Add vodka. Cover and shake. Strain into a martini glass. Top with orange juice. Garnish with orange peel twist and serve immediately.

The Garden Green Fairy

MAKES 1 COCKTAIL

1 ounce (2 tablespoons)
(30 ml) absinthe

1 sugar cube

3 ounces (6 tablespoons)
(90 ml) cold water

A popular spirit of Monet's day was absinthe, also known as *La Fée Verte*, or The Green Fairy, as it was traditionally green in color. Created in Switzerland in the late eighteenth century, it rose to popularity in France in the late nineteenth and early twentieth centuries, especially among artists and bohemians such as Monet. This high-alcohol spirit, always diluted with water, was made from the flowers and leaves of a medicinal herb known botanically as *Artemisia absinthium* (commonly called wormwood). The chemical compound thujone, found in its leaves, was later thought to have harmful side effects if drunk in excess, but more recently it is thought that absinthe is no more dangerous than other spirits if consumed in moderation. Absinthe has recently experienced a renaissance and we would feel remiss not to include a cocktail in order to savor the delicious licorice flavor that Monet and many other Impressionist painters liked.

Pour absinthe into a small martini glass. Place sugar cube in an absinthe spoon or a very small slotted metal spoon. Hold spoon over glass and drip cold water slowly over sugar cube into glass. Serve immediately.

The Baudy

MAKES 1 COCKTAIL

4 mint leaves

1 tablespoon (20 g) honey

1 tablespoon (15 ml) fresh lemon juice

1 ounce (2 tablespoons) (30 ml) Calvados

1/4 cup (150 g) crushed ice

2 ounces (1/4 cup) (60 ml) sparkling alcoholic apple cider

Mint sprig

The Baudy is the hotel on Rue Claude Monet in Giverny, where Monet, Cezanne and all of their friends would meet to have a drink and discuss art. There is a studio in back of the hotel where the artists could paint, and there is a labyrinth of paths that wander within a garden lush with pink roses. This cocktail we would describe as Normandy in a glass! Make sure to "muddle," or crush the mint to release its essential oils.

Place mint leaves, honey and lemon juice in a tall glass. Using the back of a spoon, muddle mint and dissolve honey in lemon juice as much as possible. Pour in Calvados. Add crushed ice. Stir well. Top with cider. Garnish with mint sprig. Serve immediately.

Madame Baudy

MAKES 1 COCKTAIL

3 ice cubes

1 1/2 ounces (3 tablespoons) (45 ml) Scotch whisky

1 1/2 ounces (3 tablespoons) (45 ml) Cointreau or other orange-flavored liqueur

2 dashes orange bitters

1 orange peel twist

Madame Baudy, who ran the Hôtel Baudy on the main street of Giverny, helped to introduce Scotch whisky to France. Monet was a fan of the Scottish libation, and even today at the hotel there remains an invoice that reads, "Monsieur Cezanne two whiskies with Monsieur Monet." Cointreau was often drunk as an aperitif during Monet's life. Here the two drinks come together in a smoky and citrusy cocktail that Monet and Cezanne might like to have shared at the bar or out in the rose garden.

Place ice cubes in a short glass. Pour in whisky, then Cointreau. Add bitters. Stir. Garnish with orange peel twist. Serve immediately.

The Giverny

1 1/2 ounces (3 tablespoons)
(45 ml) gin

1/2 ounce (1 tablespoon)
(15 ml) crème de cassis

1/4 cup (150 g) crushed ice

Monet stayed at the Savoy Hotel in London between 1900 and 1905, during the birth of the cocktail and when the hotel had its first great bartender, Ada Coleman—a female who delighted in mixing, shaking and stirring drinks for her discriminating clientele. Gin was a mainstay in London, both for drinks and as a medicine. Monet grew many of the botanicals and herbs that are found in gin, including anise, coriander, sage and fennel. Even dusky blue juniper berries grew in the fields around Giverny. The sweet black currant flavor and rich color of crème de cassis gives this cocktail artistic flair.

Place gin and crème de cassis into a cocktail shaker. Add ice, cover and shake. Strain into a martini glass. Serve immediately.

The Bridge

MAKES 1 COCKTAIL

6 ounces (180 ml) freshly
brewed hot coffee

1 1/2 ounces (3 tablespoons)
(45 ml) Cognac or brandy

2 tablespoons (30 ml) heavy cream

1 tablespoon chocolate syrup

Meals at the Monet home were enjoyed indoors or outdoors, depending on the weather, as guests lingered over them for hours. Spirits were served before, during and after repasts. Cognac and liqueur was often poured into glasses Monet obtained while painting in Norway, and offered alongside coffee. Here the floral warmth of Cognac enhances the classic combination of coffee and chocolate known as mocha. The gilding of the lily is the addition of heavy cream, a luscious nod to the wonderful cream of Normandy. Just imagine standing in the moonlight on Monet's wisteria-covered bridge, admiring the moon's reflection and listening to the sounds of the frogs croaking while sipping this alluring coffee. Make the coffee as strong or as weak as you like, or use espresso if you prefer.

Place coffee, Cognac, cream and syrup in a large mug and stir well. Serve immediately.

Monet's Palate

1 (750 ml) bottle dry
alcoholic cider, chilled

4 strips fresh orange peel

Apple cider is the "wine" of Normandy. While the climate of Monet's beloved region is too cold for wine grapes, it is perfect for ripening cider apples. Prior to Monet's purchase of the Pink House, the property was a farmhouse known as the *Le Pressoir* (House of the Cider Press). Imagine an autumn day when cartloads of ripe apples would be taken to the cider presses. We created this drink as a tribute to Monet and Normandy. The combination of apple bubbly with a hint of orange is as refreshing as it is novel. A toast to Monet!

Fill 4 Champagne flutes evenly with cider. Twist 1 piece of orange peel and rub along rim of flute, then drop peel into cider. Repeat with remaining peels and flutes. Serve immediately.

The Normandy

MAKES 1 COCKTAIL

6 ounces (180 ml) nonalcoholic
apple cider or apple juice

1 tablespoon (15 ml)
fresh lemon juice

1 1/2 teaspoons (7,5 ml)
smooth applesauce

Ice cubes

Cinnamon stick

Monet's good friend Cezanne traveled from Provence to Paris seeking artistic recognition. When he arrived, he declared to a party of fellow painters, "Give me an apple and I will conquer Paris," meaning that all he required to prove his artistic talent was to paint a still life of apples. Perhaps Monet followed Cezanne's lead as one summer he planted tall sunflowers to mingle their yellow flowers with ripening orange-and-red-skinned apple fruits to paint them. This image survives today in a photograph taken at the side of his kitchen garden. Monet's love for the traditional Norman fruit showed up in his canvases—many of his most beautiful still lifes included the *pommes*—as well as on his dining table. And a glass of cider was never far from hand. Here we have created a nonalcoholic cocktail starring the apple that is perfect for young and old alike.

Place cider, lemon juice and applesauce in a tall glass and stir very well. Add ice cubes and garnish with cinnamon stick. Serve immediately.

NORMANDY APPLE CIDERS

Cidre, or apple cider, is a refreshing fermented alcoholic drink made from the juice of apples, which Monet enjoyed at table and served at picnics. In addition to traditional cider there are Calvados—a stronger alcoholic drink made from apples and generally served as a liqueur—and Pommeau—a mix of apple juice and apple brandy, served as an aperitif.

Apples for cider making are classified as bitter, sweet bitter, or sweet and acidic, resulting in varying degrees of sweet and dry ciders. To vary the flavor, ciders are often mixed with other ingredients such as ginger. A district south of the A13 between Rouen and Caen contains Normandy's "Route du cidre." Follow signs that clearly mark the route and identify orchards and estates that have tasting rooms. Ciders marked Cidre de Cambremer or AOC (Appellation d'origine contrôlée) are made to especially high standards, as strict as those for the manufacture of wine.

Impression Sunrise in the Garden

MAKES 1 COCKTAIL

1 teaspoon (7 g) honey

2 mint leaves

6 ounces (¾ cup) (180 ml) blood orange juice

¼ cup (150 g) crushed ice

2 ounces (¼ cup) (60 ml) club soda or other sparkling water

Mint sprig

Monet's painting *Impression Sunrise* depicts the Normandy coastal harbor of Le Havre from a room at a house overlooking the inner harbor or *basin*. The misty blue overtones of the canvas and crimson-red sun reflecting on the still inner harbor are so beautiful. We have created this nonalcoholic cocktail as homage to the painting said to have given rise to Impressionism.

Place honey and mint leaves in the bottom of a tall glass. Add orange juice. Using the back of a spoon, muddle mint and honey into juice. Add crushed ice. Stir well. Top with club soda. Garnish with mint sprig. Serve immediately.

La Ferme (The Farm)

MAKES 1 COCKTAIL

3 ice cubes

3 ounces (6 tablespoons) (90 ml) nonalcoholic apple cider

1½ ounces (3 tablespoons) (45 ml) Cognac

1 lemon peel twist

When the trees are laden with fruit and cider is being pressed, the aroma of apples in the air is at its strongest and most seductive in Normandy. No doubt this inspired Monet to put brush to canvas to capture a signature tableau of his region. In this refreshing yet warming cocktail, we combine cider with Cognac; Monet would have loved it. This goes unusually well with blue-veined cheese, so pair with Roquefort toasts for an easy appetizer.

Place ice cubes in a short glass. Add cider and Cognac and stir well. Garnish with lemon peel twist and serve immediately.

The Water Lily

MAKES 1 COCKTAIL

2 ounces (¼ cup) (60 ml) chilled vodka

½ ounce (1 tablespoon) (15 ml) Cointreau or other orange-flavored liqueur

½ ounce (1 tablespoon) (15 ml) Chambord

¼ cup (150 g) crushed ice

1 lemon peel twist

Monet's water garden is at its best in early summer when the water lilies start to bloom. The garden was the inspiration for a series of approximately 250 oil paintings that were the main focus of Monet's artistic production during the last 30 years of his life. This cocktail captures the color of the red water lilies that captivated Monet when he saw them exhibited at a World's Fair held in Paris. This cocktail is as beautiful as Monet's water garden and painting—thanks to the raspberry color of Chambord—and is absolutely delicious.

Place vodka, Cointreau and Chambord in a cocktail shaker. Add ice. Cover, shake and strain into a martini glass. Garnish with lemon peel twist and serve immediately.

Acknowledgments

I would like to thank my dear mother, Helen Rappel Bordman, who since 1980 has been largely responsible for the renaissance of Monet's home and garden. I am grateful to Claudette Lindsay and Laurent Echaubard of Fondation Claude Monet for their kindness during all these years; to first head gardener Monsieur Gilbert Vahé, who planted the seeds of Giverny's renaissance, and to his successor, James Priest, who now carries the baton. Thanks to Hugues R. Gall, Director of Fondation Claude Monet, for his kindness. I owe a debt to Meryl Streep, my friend, for her continuing support of Monet's Palate and to my agent Deborah Ritchken, my editor Madge Baird, Steven Rothfeld and Karen Kaplan; also to Derek Fell, garden writer and photographer for helping to create this special homage to Monet. Last, but not least, I thank the late Gerald and Florence Van der Kemp, who gave us all the opportunity to be stewards of Claude Monet's home and gardens at Giverny.

— AILEEN BORDMAN

Thanks to my mentors, the late Harry Smith, horticultural photographer, who taught me to photograph gardens; the late E. O'Dowd Gallagher, foreign correspondent, who taught me to write; and the late David Burpee, dean of American seedsmen, who taught me a great deal about plants and gardening. I am also thankful to Hiroshi Makita, Zen landscape designer, who taught me concepts of Japanese garden design that allowed me to interpret Monet's water garden, and my supportive wife, Carolyn, a color specialist for the fashion industry, who helped me identify Monet's favorite color harmonies and re-create aspects of his kitchen garden at our home, historic Cedaridge Farm. My hardworking coauthor, Aileen, also proved to be a big inspiration.

—DEREK FELL

About the Authors

AILEEN BORDMAN is a filmmaker and founder of Monet's Palate, Inc., a company dedicated to sharing the world of Claude Monet. Her mother, Helen Rappel Bordman, helped restore the gardens at Giverny and has been the American representative in residence each spring since 1980. A plaque at Museum Claude Monet Giverny honors her vital contribution and association with Monet's home and garden.

Aileen has been immersed in the world of Claude Monet since 1980 and has more than thirty years of firsthand experience at Monet's home and gardens. Her knowledge and passion with respect to Claude Monet's lifestyle, cuisine, gardens and art prompted the creation of the Monet's Palate concept.

Aileen independently wrote and produced the film *Monet's Palate,* which features Meryl Streep, Alice Waters, Joachim Pissarro, Helen Rappel Bordman, Daniel Boulud, Roger Vergé, Anne Willan, Steve Wynn and Michel Richard. The film has been screened from Cannes to New York and was featured during the six-month "Monet's Garden" exhibit at the New York Botanical Garden in New York City.

DEREK FELL was born and educated in England and became an American citizen in 1970, when he embarked on a career of writing garden books using his own photography. His series of books about the great Impressionist painters has received wide acclaim and publication in numerous foreign languages. These works include *Renoir's Garden, The Magic of Monet's Garden, Cezanne's Garden* and *Van Gogh's Gardens.* For more than twenty years he has also produced a wall calendar titled *Monet's Garden,* and during the Ford Administration he was a consultant to the White House on vegetable gardening.

Derek has won more awards from the Garden Writers Association than any other person. His father was one of the great chefs of Europe, trained by Cunard cruise lines, and for six years Derek hosted the popular QVC television garden show *Step-by-Step Gardening.* He publishes the monthly on-line gardening newsletter, the *Avant Gardener.* He owns the only known painting of Monet's kitchen garden and lives with his wife, Carolyn, at historic Cedaridge Farm, Bucks County, Pennsylvania. There he cultivates gardens inspired by the Impressionist painters and enjoys visits by his three adult children and three grandchildren. He also cultivates a frost-free, subtropical garden on Sanibel Island, Florida.

Index

Featured Paintings

Metric Conversion Chart

VOLUME MEASUREMENTS

U.S.	METRIC
1 teaspoon	5 ml
1 tablespoon	15 ml
¼ cup	60 ml
⅓ cup	75 ml
½ cup	125 ml
⅔ cup	150 ml
¾ cup	175 ml
1 cup	250 ml

WEIGHT MEASUREMENTS

U.S.	METRIC
½ ounce	15 g
1 ounce	30 g
3 ounces	90 g
4 ounces	115 g
8 ounces	225 g
12 ounces	350 g
1 pound	450 g
2¼ pounds	1 kg

TEMPERATURE CONVERSION

FAHRENHEIT	CELSIUS
250	120
300	150
325	160
350	180
375	190
400	200
425	220
450	230

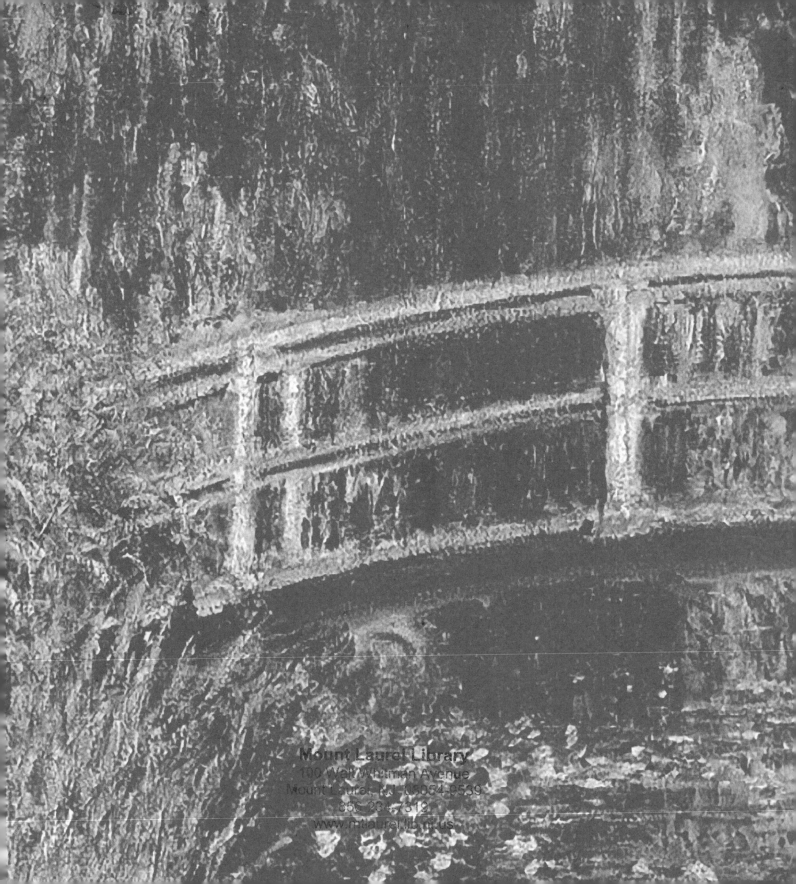